HISTORIC FIRSTS *of*
LEWISTON
IDAHO

HISTORIC FIRSTS *of*
LEWISTON
IDAHO

UNINTENDED GREATNESS

STEVEN D. BRANTING

THE
History
PRESS

Published by The History Press
Charleston, SC 29403
www.historypress.net

Cover image: Courtesy of Barry Kough, photo editor, *Lewiston Tribune*.

Unless otherwise indicated, all images in this book have been gleaned from the
archives of the Nez Perce County Historical Society.

First published 2013
Second printing 2014
Third printing 2014

Manufactured in the United States

ISBN 978.1.60949.912.9

Library of Congress Cataloging-in-Publication Data

Branting, Steven D.
Historic firsts of Lewiston, Idaho : unintended greatness / Steven D.
Branting.
pages cm
ISBN 978-1-60949-912-9
1. Lewiston (Idaho)--History--Miscellanea. 2. Lewiston (Idaho)--
Biography--Miscellanea. I. Title.
F754.L6B73 2012
979.6'85--dc23
2013000666

For my wife, Shann, whose healthy skepticism effectively prodded me to prove to her that I knew what I was talking about.

ACKNOWLEDGEMENTS

The assistance of Mary E. White-Romero, museum assistant at the Nez Perce County Historical Society, was invaluable in the preparation of this volume.

American humorist Will Rogers once quipped, "It's not what you don't know that hurts you; it's what you do know that ain't so." A failure to clearly annotate historical research with primary sources perpetuates speculation, misinterpretations and poor scholarship. The reader will find citations provided for most of the entries. Future historians deserve to know my sources, especially when that information relates to junctures of circumstances in the record of events.

And lastly, a few comments about evidence: Absence of evidence is not evidence of absence. No one on the

frontier anticipated being the first to do anything. William Shakespeare did not know he would become *the* William Shakespeare. In several instances in this story, the clues converge, not to an absolute, definitive point, but to a degree of high probability, conclusions based on the best evidence. That probability is so noted in several entries. If history were so clear, certain and concise, we wouldn't have such a need for historians to reconstruct events no one took seriously at the time.

INTRODUCTION

A people which takes no pride in the noble achievements of remote ancestors will never achieve anything worthy to be remembered with pride by remote descendants.
—Thomas Macaulay

Each village, hamlet, town and city has a multitude of stories to tell, varied as communities are by the personalities that came together to create their culture. Lewiston, Idaho, is certainly no different. It, too, has crowed with the joy of pride when someone in its ranks achieved notoriety. It, too, has suffered the anxious moments of "pestilence that walks in the gloom," only to step back, reassess and move forward. Growing pains require people who are not afraid to change from necessity and opportunity

to be ready for the unexpected and to come up with other solutions. As Émile Chartier wrote in *Propos Sur la Religion*, no. 74, "Nothing is more dangerous than an idea when it is the only one you have."

On October 10, 1805, the Lewis and Clark Corps of Discovery first visited the site where Lewiston would appear more than fifty years later. Lewis wrote in his famed *Journal*:

> *The Countrey about the forks is an open Plain on either Side I can observe at a distance on the lower Stard. Side a high ridge of Thinly timbered Countrey the water of the South fork is a greenish blue, the north as clear as cristial...worthey of remark that not one Stick of timber on the river near the forks and but a fiew trees for a great distance up the River.*

The corps camped nearby for one night and continued on its journey to the Pacific.

Decades of quiet activity by fur traders would pass. Deeming the region of seemingly little economic importance, the federal government allocated the area to the Nez Perce tribe as a reservation in 1855. The discovery of gold in the Clearwater basin in 1860 and the outbreak of the Civil War ensured the creation of a new territory that would strengthen the Union cause.

Lewiston began as a motley collection of treasure seekers, opportunists, dance hall girls, Chinese laborers and scoundrels, with, of course, those searching for better lives

thrown in. To say that Lewiston's genesis was some frontier birth of Venus would ignore the evidence. Quite frankly, it was a town never intended to last beyond the short-lived rapture of the central Idaho gold rush in the early 1860s. And yet, Lewiston bore the trademark of the great cities of the world: It put down its roots on the banks of a major river (in its case, two—the confluence of the Snake and Clearwater). The native *Ni-Mi'i-Puu* (Nez Perce) called it *tsceminicum*, "meeting of the waters."

Lewiston started simply enough. On May 13, 1861, the *Colonel Wright*, the first stern-wheeler to run the Snake River, tied up at the confluence. Launched on October 24, 1858, the 110-foot-long boat was making the run between Walla Walla to Portland when called into service to go up the Snake River toward the new gold fields. Captain Leonard White commanded the *Colonel Wright* for several years, having mastered his skills on the Willamette River in Oregon. White unloaded his cargo of stores and prospectors and returned downstream. By October 1861, reports were circulating in Walla Walla that a town site had been established, much to the chagrin of the agent at the Nez Perce reservation, which at that time stretched from La Grande, Oregon, to the Lolo Pass on the border of present-day Montana. The richness of the river basins and their bounty heightened the sense of opportunity for those who had faith in the fledgling collection of tents and rough-hewn lumber. Lewiston's population would, for a time, surpass that of Seattle and Portland combined. And that is where our story begins.

Historic Firsts of
Lewiston, Idaho

1861: Idaho's First Police Department

The facts are always less than what really happened.
—Nadine Gordimer

The January 25, 1862 issue of the *Washington Statesman* (Walla Walla) carried the article "Police Organization at Lewiston," relating recent events in the young community during the last few months of 1861. People were buying and selling lots, forming businesses and instituting a city government—all in violation of the Treaty of 1855 with the Nez Perce. In July 1861, A.J. Cain, the agent for the Nez Perce, had protested that locals were developing a community that "cannot be permitted under any circumstances." Cain threatened to tear down any permanent buildings placed on the land. Residents reacted

by erecting framed canvas tents. At night, the temporary homes glowed with fireplaces. The flimsy canvas dwellings nearly caused the town's demise in the winter of 1861–62, one of the region's most severe on record.

Among the events reported on by the *Statesman* was the fact that Lewiston's squatters, who were described as "men of towering ambition," had appointed a town constable, Idaho and Lewiston's first policeman: Edward Everett, who then disappeared from the historical record. Being a lawman during Lewiston's infancy could be very dangerous. At 10:00 a.m. on March 30, 1865, word reached Lewiston that territorial secretary Clinton DeWitt Smith

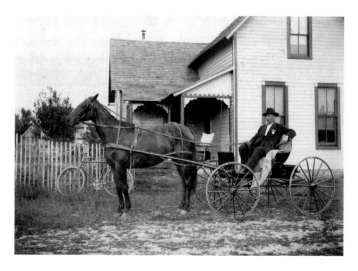

City marshal, circa 1890.

and a detachment of troops from Fort Lapwai were headed for the town to take custody of the territorial seal and important documents. Rumors spread that the detachment would burn the community. Town leaders calmed the crowds that gathered to defend the town. Some of the soldiers took control of the Clearwater River ferry, while others, ignoring the presence of the deputy marshal, J.K. Vincent, broke the lock on the executive office building on Third Street. With the seal and official materials in hand, Smith and his escort crossed the Snake River by ferry into the Washington Territory and out of the jurisdiction of Lewiston's law enforcement officials.

Since 1861, the Lewiston Police Department has lost five officers in the line of duty, more than any other department in the state. See "1862: Idaho's First Vigilante Association."

Idaho State Historical Society. Reference Series #766. 1983.

1861: IDAHO'S FIRST RESIDENT PHYSICIAN
(BASED ON THE BEST EVIDENCE)

English-born Dr. Henry Stainton (1831–1890) did his postgraduate work at St. Bartholomew's Hospital in London and served as a ship's physician for two years. In the 1850s, he settled in the Willamette Valley and established a lucrative practice. The great floods of 1861

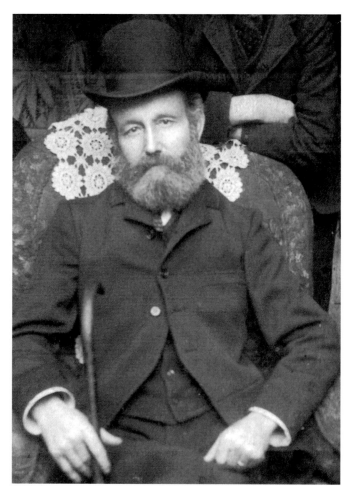

Dr. Henry W. Stainton.

destroyed his holdings, forcing his relocation to newly settled Lewiston. In 1867, he was elected city treasurer. At its November 6, 1871 meeting, the city council took action to authorize Mayor Levi Ankeny to submit a land entry on behalf of the city to secure a town site designation. After 1866, Lewiston was not on the Nez Perce reservation but was still classified as public domain. No one could acquire title deed to property without a patent from the federal government. Many did not. So people who built homes and businesses in Lewiston were, by definition, still squatters. Ankeny procrastinated, and no action was taken until Dr. Stainton became mayor on April 6, 1874. A formal survey was conducted by Edward B. True and filed with the federal government. On April 10, 1875, President Ulysses S. Grant signed the town site papers for the city, allowing real property to be properly deeded by a city official. Mayor Stainton would act as that trustee. See "1863: Idaho's First Incorporated Settlement" and "1869: North Idaho's First Government Land Office."

Hawley, James. *History of Idaho: Gem of the Mountains*. Vol. 4. Chicago: S.J. Clarke Publishing, 1920, 358.

1862: IDAHO'S FIRST FEMALE HOTEL KEEPER
(BASED ON THE BEST EVIDENCE)

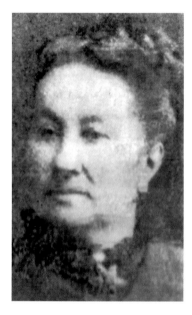

Melanie Le François.

Among Lewiston's early important establishments was the Hotel De France, operated by Melanie Snider Bonhore, a Parisian dealer "in ladies' furnishings and fancy goods." A small woman who dressed impeccably in the latest fashions decked with jewelry, she found Lewiston's accommodations dirty, limited and provincial when she arrived in April 1862. She set herself a goal of building the finest hotel "in the north country." Before she could obtain the proper lumber, she purchased a circus tent and outfitted it for prospectors passing through Lewiston to the gold fields. She was an experienced hotelier, having managed a hotel in Grass Valley, California, before it burned in a fire that consumed the entire area. Her husband, Paul, died soon after they

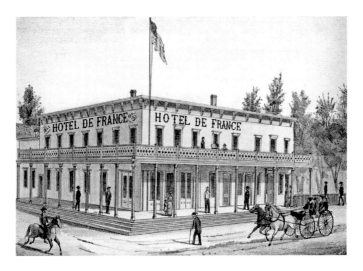

Hotel De France, 1884. *From* History of the Idaho Territory.

arrived, but she would not change her plans for a new hotel, which was eventually built on the corner of Second and C (now Capital) Streets. She married Charles Le François, a cattleman, but he died in 1874, leaving her to manage alone. Because the establishment and its furnishing were so elegant, it was a favorite site among brides for their weddings. Madame Le François died on April 13, 1897. The oldest sections of the hotel were razed in 1945, leaving one brick wing, which serves now only for storage.

History of the Idaho Territory. San Francisco: Wallace W. Elliott & Co., 1884, 282.

1862: IDAHO'S FIRST RESIDENT DENTIST
(BASED ON THE BEST EVIDENCE)

In a dispatch to the *Oregonian*, P.W. Gillett wrote of his journey up the Columbia and Snake Rivers to Lewiston. His entry of May 12, 1862, stated that "Lewiston is a brisk place. There are stores and shops of every sort, law, doctor, dentist and express offices." The dentist in question was Dr. Francis (Frank) C. Clark. He was born in Waldo County, Maine, in 1829, the descendant of a *Mayflower* family. He lived there until 1850, when he was drawn to California by accounts of the rich gold fields. His trip as a passenger on the bark *Mitas* around Cape Horn took 140 days. After work in San Francisco and mining led to limited success, Clark studied dentistry, practicing first in California before coming to Idaho. In his first newspaper advertisement, he wrote, "Those having decayed teeth who desire fine finished and durable fillings can obtain my services at reasonable prices." By 1870, Clark had moved to Council Bluffs, Iowa, where he continued his practice and became active in the Iowa State Dental Society.

Golden Age, August 2, 1862, 1.

1862: IDAHO'S FIRST ASSAY OFFICE
(BASED ON THE BEST EVIDENCE)

Two candidates vie for the honor of opening the first assay office: Richard Hillard Hurley and John Proctor, both of whom arrived in the city in 1862. Raised in upstate New York, Hurley worked as a machinist in New York City, a silver miner in Mexico and a businessman in California. Floods wiped out his interests in Oregon City, Oregon, in 1861. Discouraged, he gave up his foundry and machinist company and studied assaying. In

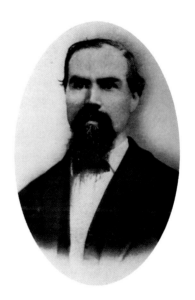

Richard Hillard Hurley. *Courtesy of the City of Portland, Oregon Archives.*

the spring of 1862, Hurley moved to Lewiston, where he established an assay office on the corner of Capital and Third Streets, remaining here until 1873 or 1874, when he returned to Portland. Little is known about John Proctor other than that he sold his business to John Brearley in 1863 and became involved with businesses and landholdings in and around

Cottonwood, Idaho, where he owned the Cottonwood Hotel. By 1872, he was listed as one of the wealthiest men in Nez Perce County. By the 1890s, Proctor had moved to San Francisco and handed the management of his real estate to Samuel Goldstone, son-in-law to Abraham Binnard. The first U.S. Assay Office in Idaho did not open until 1872. See "1863: Idaho's First Banks."

Gaston, Joseph. *Portland, Oregon: Its History and Builders*. Vol. III. Chicago: S.J. Clarke Publishing, 1911, 648.

The Illustrated History of North Idaho. San Francisco: Western Historical Publishing Company, 1903, 83.

1862: IDAHO'S FIRST JEWISH PERMANENT RESIDENT

A native of Poland, Robert Grostein grew up in Buffalo, New York, where he worked in his father's store. He made his way to California in 1854 to mine gold, arriving with one dollar (twenty-two dollars today) in his pocket. By 1856, he had saved enough money to open a store in The Dalles, Oregon. In 1862, Grostein became the first documented Jewish resident of the Idaho Territory. He married Rosa Newman of Sacramento, California, in 1864. Over the course of his business career, he built several public buildings and "one of the finest residences" in the city, owned 3,500 acres of farmland and operated

Robert Grostein home, circa 1885.

strings of pack mules to supply mining camps. All of the old Lombard poplars that once filled downtown Lewiston are said to have descended from a twig he used to urge on the reluctant mule that carried him to Lewiston. He was joined in business in 1865 by his brother-in-law, Abraham Binnard, with whom he owned much of downtown Lewiston for several decades. Grostein died in 1907. See "1865: Idaho's First Jewish Child" and "1881: Idaho's First Legitimate Theater." See also "1903: Idaho's First Exclusive Mortuary."

An Illustrated History of the State of Idaho. Chicago: Lewis Publishing Company, 1899, 403–5.

1862: IDAHO'S FIRST POST OFFICE

Almer L. Downer, circa 1895.
Courtesy of the Shasta Historical Society, Redding, California.

On July 1, 1862, Lewiston was officially assigned a post office in the Washington Territory. Almer Lawrence Downer was appointed postmaster on July 15 and opened the office on July 25. Born in 1807, Downer came to California via the Isthmus of Panama in the 1849 rush and settled in Shasta County, becoming a prominent businessman in Sacramento. After his term as postmaster, he would later serve as clerk of the Idaho Supreme Court. He returned to California in 1866 and became active in local politics. Downer died on March 2, 1898. Regular postal routes were already running between Walla Walla and the gold fields at Pierce City, Oro Fino, Elk City and Florence, all of which passed through Lewiston. Produce wagons carried the mail, with deliveries once a week. By 1863, the postmaster was requesting a three-times-a-week schedule.

The earliest physical description of the location for the Lewiston office dates from March 1871, when

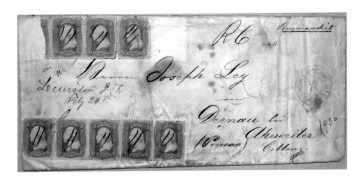

Envelope mailed from Lewiston Post Office, February 24, 1865.
Courtesy of Matthias Bertram.

postmaster Charles Thatcher listed it as being two hundred feet from the east bank of the Snake River and 250 yards from the south bank of the Clearwater River. That placed the post office along First Street between Main and D Streets. Early post offices in the West were often housed in local businesses, the owner of which was the postmaster. However, an 1868 county tax rolls map places the old courthouse at that location. Based on this evidence, Downer used the courthouse (now the site of the Lewis-Clark Hotel), as he did not own a business in Lewiston during his residence. The next verified site based on a map was at the head of Second Street on Main, in the jewelry store of Charles G. Kress, who became postmaster on May 5, 1885, in the wake of the arrest of Isaac N. Hibbs. Hibbs had written at least $20,000 ($473,000 today) worth of fraudulent money

orders and fled with the money to Canada, where he was arrested by the North-West Mounted Police (now the Royal Canadian Mounted Police) and transferred to the provincial jail in Victoria, British Columbia, to await extradition. The office subsequently moved to various sites along Main Street, including the first Elks Lodge, until 1912, when a new federal building was erected. That structure is now Lewiston City Hall.

Idaho State Historical Society. Reference Series #103. 1963. United States Postal Service

1862: IDAHO'S FIRST NEWSPAPER

Lewiston's pioneers longed for the news, paying up to $2.50 ($54.00 today) for a single issue of a California newspaper. A pro-Union activist, A.S. Gould, published the first issue of the *Golden Age* on August 2. On one occasion, when Gould raised the American flag on a pole by his office, "21 shots were fired into it by disunion Democrats." The first issue was produced from a hand press in an old office on Third Street and was dominated by accounts of the treaty negotiations with the Nez Perce. Gould left Lewiston within a year, and operations were taken over by Frank Kenyon and then Alonzo Leland. One of the oldest-known original copies was found in a bundle of old newspapers in a

barn near New Haven, Connecticut, in the 1920s. A book dealer got possession of it. The document finally made its way into the collection of Lewiston State Normal School (now Lewis-Clark State College). The *Golden Age* was published each Saturday as a small, four-page, six-column newspaper. The motto "Je maintiendrai le droit" can be translated as "I shall maintain the right." Published until 1865, the *Golden Age* was Lewiston's major link to the outside world. Lloyd Magruder's name would be carried by even San Francisco newspapers within a year, after his

The *Golden Age* (detail), September 5, 1863.

THE GOLDEN AGE.

"Je Maintiendrai Le Droit."

LEWISTON, I. T.

Saturday, September 5, 1863.

Mr. Lloyd Magruder.

It will be seen by reference to this gentleman's circular, on our first page, that he starts out by boldly announcing to his friends that he is a "Democrat, Copperhead or Butternut;" that he adheres "to the tenets of that party," and authorizes them to use his name as a candidate to represent Idaho Territory in the ensuing Congress, subject to the action of a Convention of that party. He further intimates that the position of Delegate to Congress is "most honorable," and one the he would be "proud to occupy," that is to say, "if his views on the vital issues of the times correspond with those of his fellow citizens." The latter subjunctive clause is well put in—*if* his "fellow citizens" look through the same green-eyed spectacles that he does. *If* the fanatical bigotry writhing to the surface through every pore of his skin has a lodgment under the integument of his *fellow citizens*, then of course Mr. Lloyd Magruder would be very proud to represent them in the halls of Congress. Now, Lloyd, there is'nt a shadow of a doubt in the minds of observing men that "your views" are entertained by every secessionist in Idaho, by every Copperhead sympathiser of Jeff. Davis and his hell-hounds engaged in the laudable (?) work of squelching out the Union sentiment in the South with fire and sword, by every mobocratic ruffian whose festering carcass mingled so recently with the great crowds in New York City for the laudable (?) purposes of plunder, arson and murder. But thanks to the intelligence of the hardy yeomanry of this Territory, your kind constitute nothing like a majority of its legal voters; hence we infer that you will be "weighed in the balance and

murder and subsequent capture of his assailants by Hill Beachey, the proprietor of the Luna House hotel.

The *Golden Age* folded in January 1865, shortly after the territorial legislature declared Boise to be the new capital, and its equipment eventually ended up there. Lewiston's earliest newspapers were short-lived. Lewiston lacked a paper until Thomas J. Favorite founded the *North Idaho Radiator* the next summer. He and his printing press followed the gold rush to Montana within a few months. Readers waited until January 17, 1867, and the appearance of William Mahoney and Seth S. Slater's *Lewiston Journal*, a weekly that was taken over by Alonzo Leland and his son Henry in 1868. Individual copies sold for fifty cents (eight dollars). Within a month after the *Journal* folded in February 1872, the Lelands and Robert A. Rowley started the *Idaho Signal*, which remained in print until September 1874 and dropped prices to twenty-five cents (five dollars) an issue. W.C. Whiston and J.M. Dormer published the *Northerner* from September 1874 to June 1875. The first newspaper of any permanence proved to be Alonzo and son Charles Leland's *Lewiston Teller*, which began as a weekly in 1877 and was published from a print shop on the corner of Second and Main Streets. Sold to Charles A. Foresman in 1890, the *Teller* converted to a daily in 1900 and continued publication until 1909. From September 1880 to July 1888, the *Teller* competed with the *Nez Perce News* for readers. See "1898: Idaho's First Newspaper to Receive Telegraphic News Dispatches."

Idaho State Historical Society. Reference Series #373. 1966.

Spokane [Washington] *Daily Chronicle*, August 2, 1962, 13.

1862: IDAHO'S FIRST PHOTOGRAPH (BASED ON THE BEST EVIDENCE)

August 1862 found Edward M. Sammis in Lewiston, a part-time whiskey bootlegger who had turned to photography, particularly landscapes. He set up a studio on D Street, but his advertisement in the *Golden Age* stated that he would be returning to Walla Walla in only ten days. The following month, the Olympia, Washington *Standard Age* reported that Sammis had recently sent the editors a panoramic photograph of Lewiston. P.W. Gillette's comments match the photo very well:

> *The town is built of canvas, poles, logs and split boards. Town lots are all the rage. Everybody is buying lots, selling lots, squatting on lots, jumping lots and lawing about lots. Yet Lewiston is situated upon an Indian reservation, and no one has any title to the lots, save squatter's rights, squatter's sovereignty. Lots are selling at $50* [$1,100 today] *to $1,000* [$22,000].

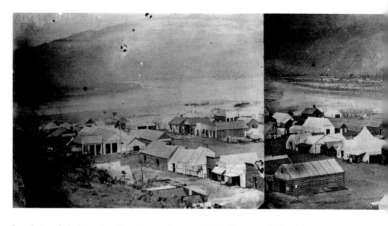

Lewiston, Washington Territory, August 1862. *Courtesy of Special Collections and Archives, University of Idaho Library.*

The first issue of the *Golden Age* carried advertisements with locations of businesses specific to streets and intersections, confirming the earlier reports that an illegal city was taking shape.

Palmquist, Peter E., and Thomas R. Kailbourn. *Pioneer Photographers of the Far West: A Biographical Dictionary, 1840–1865.* Stanford, CA: Stanford University Press, 2000, 474.

1862: IDAHO'S FIRST BREWERY

The Weisgerber family emigrated from Germany in the 1840s and settled in West Virginia. Three brothers—Ernst,

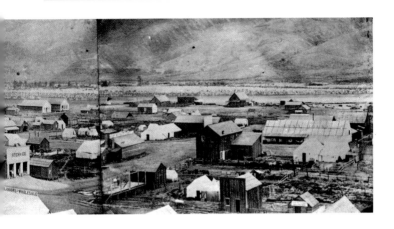

John and Christ—tried their hand as cheese makers and butchers, but beer would be their claim to fame and fortune. Ernst arrived in Lewiston in 1862 and leased a portion of the Robert Newell estate to establish the California Brewery. On October 16, 1863, he purchased a building located on First Street and began buying up the nearby property. John joined the firm in 1869 and Christ in 1870. In September 1875, Ernst sold the business to his brothers and left for the East, where he died a few years later.

Breweries were common sights in large and small towns in the late nineteenth century. In the days before dependable refrigeration, shelf life for beer was very short. A small outlet store sat next to the brewery, although most of the beer was sold to saloons in Lewiston. After John died in 1890, Christ continued as sole owner, adding ice production to the business and eventually installing a ten-

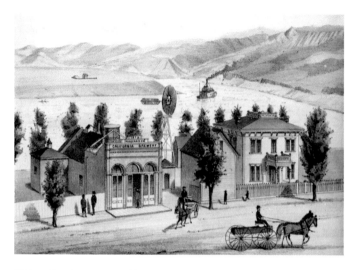

Weisgerber brewery and home, 1884. *From* History of the Idaho Territory.

ton ice-making machine. The brewery closed in 1913, when Nez Perce County passed a prohibition bill. The building was leased to the Mason-Ehrman Company, a dry goods firm that used it as a warehouse. On February 7, 1936, a fire broke out in the warehouse and destroyed the structure.

History of the Idaho Territory. San Francisco: Wallace W. Elliott & Co., 1884, 281.

1862: IDAHO'S FIRST
VIGILANTE ASSOCIATION

Early Lewiston was far from a safe place, frequented as it was by the likes of Henry Plummer, whose gang is said to have included every scoundrel between Lewiston and Virginia City, Montana. Robert Grostein reported a murder the first night he spent in town, which had its own vigilante committee: the Lewiston Protective Association, said to number more than 25 men "kept continually on duty." As many as 250 local residents belonged to the organization at one time or another.

Lewiston policemen have had to defend themselves from local vigilantes. On November 8, 1862, members overpowered the guards at the city's jail on First Street and took Dave English, Bill Peoples and Charley Scott "into custody." They had robbed the Berry brothers at gunpoint as the brothers carried supplies to Lewiston from Florence. The three were found dead the next morning, "hanging by the neck" in a barn. Association leaders claimed that the group had rid Lewiston of two hundred thieves and gamblers by April 1863, when the executive committee met for the last time and disbanded, just three months before the arrival of territorial governor William H. Wallace, who undoubtedly would have insisted on the group's dissolution.

On January 2, 1893, Lewiston experienced a brief but deadly resurrection of the vigilante spirit. Albert B. Roberts

had been employed as a farmhand by John Sutherland near Leland, Idaho. Sutherland discharged Roberts and withheld $5.00 ($120.00 today) in pay over a dispute about some missing money. Roberts confronted Sutherland later in town, and a fight broke out, with Roberts pulling his revolver and killing Sutherland with three shots to the abdomen. Roberts was arrested and brought to Lewiston. A masked mob of probably a dozen men arrived at the town jail and forced its way in, overpowering Deputy W.W. Wright. Newly elected sheriff Eben Mounce was alerted by gunshots from his deputy. The mob made its escape with Roberts, whose warm but lifeless body was found near the Wesley Mulkey mill (now the site of the old train station). No one in the mob was ever identified.

Idaho State Historical Society. Reference Series #166. 1980. *Idaho State Journal*, March 26, 1976, 30.

1862: IDAHO'S FIRST MASONIC LODGE

A dispensation was granted on December 23, 1862, by the grand master of Washington to "open and form a new lodge at Lewiston, Nez Perce County." In 1864, a charter was issued to what was then Lewiston Lodge No. 10, Grand Lodge of Washington. By December 1865, the lodge had surrendered its charter and passed out of existence. The

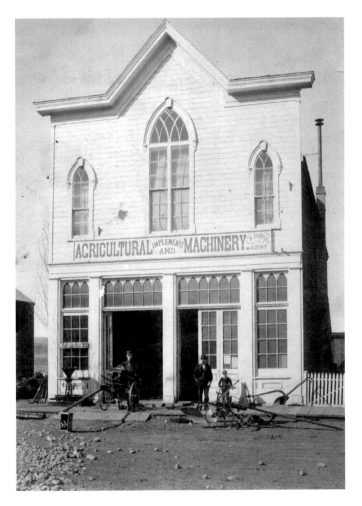

Masonic Lodge, circa 1890.

gold-mining excitement had subsided, and many masons had left for other places, leaving the lodge with insufficient members to properly maintain its operations. The lodge was rechartered on December 15, 1874. After renting space on Main Street, the lodge moved into the second floor of the Coburn Hardware Building on First Street. Chester P. Coburn was a charter member of the lodge and was its first high priest, serving in that capacity for seven years. He was also master of the lodge and grand master of the order in the state. The building was destroyed by fire on September 27, 1904.

An Illustrated History of the State of Idaho. Chicago: Lewis Publishing Company 1899, 523.

Upton, William H., et al. *Masonic History of the Northwest, Chapter XXII*. San Francisco: The History Publishing Company, 1902.

1863: IDAHO'S FIRST PUBLIC UTILITY

Idaho's first public utility services date to an act of the Washington territorial legislature, passed on January 12, 1863, which authorized Hill Beachey and his associates "to make and sell gas to light the town of Lewiston." The prevailing method of the time produced "town gas" by the destructive distillation of coal to coke. The resulting gas was suspended in water

and piped to homes and businesses. The venture does not seem to have progressed very far, as Beachey left Lewiston soon after the Magruder murderers were hanged in 1864. On March 14, 1904, the city council granted George Thayer a franchise to operate and maintain a gas plant in Lewiston. The ordinance provided that the plant would be in operation within a year and that the franchise would be

Hill Beachey.

good for twenty-five years. The maximum rate to be charged was set at $2.50 ($59.00) per one thousand cubic feet of gas, which is equal to ten therms today. The 2013 rate for ten therms of natural gas is $8.05. The plant would be built at the base of Twenty-first Street, where Hahn Supply is now located.

Laws of the Washington Territory. L. & P., 1862, 51–52.

1863: IDAHO'S FIRST
INCORPORATED SETTLEMENT

Dr. Madison A. Kelly.

On January 15, 1863, the Washington territorial legislature enacted a charter incorporating the city of Lewiston. The city limits were set. Madison A. Kelly was named mayor, with Hill Beachey, D.M. Lessey, F.H. Simmons, William Kaughman and James McNeil as members of the council. A graduate of Jefferson Medical College (now Thomas Jefferson University, Philadelphia), Dr. Kelly went west to California in 1858, marrying Abbie Gordon in 1862. Their marriage is said to have been a very special one. The couple arrived in Lewiston on April 15 of that year. Dr. Kelly was the attending physician at the execution of Lloyd Magruder's murderers in 1864, pronouncing the men dead after they had been hanging for thirty minutes. He also served as Nez Perce County treasurer and on the city council. As early as 1873, he joined other town leaders in requesting annexation into the Washington Territory.

When the Idaho Territory was created on March 4, 1863, the laws of the Washington Territory were no longer valid. This seems to have applied to the city charter, as seen by the verdict in the case of *People v. Williams* (1 Idaho 85), where the court found that a defendant cannot be indicted for a crime if the crime is not defined by law. Lewiston would have to start over. A new charter was enacted by the Idaho territorial legislature on December 27, 1866.

Laws of the Washington Territory. L. & P., 1862, 43–51.

1863: IDAHO'S FIRST FEMALE JAIL EMPLOYEE (BASED ON THE BEST EVIDENCE)

The September 2, 1942 issue of the *Spokesman-Review* (Spokane, Washington) reported that in 1863 "the city had a depot matron." While the role of that unnamed woman is very different today, historically matrons performed many domestic duties, including meal preparation. These female jail monitors once worked much like housemothers, tending to the needs of convicts to ensure the safe running of the jail. The old jail was located on First Street, on the site now occupied by the landmark Lewis-Clark Hotel. See "1864: Idaho's First Territorial Prison" and "1974: Idaho's First Female Police Officer."

1863: IDAHO'S FIRST FRUIT ORCHARD

*In the fall of 1863 Wesley Mulkey, one of the pioneers
of Lewiston, prepared a tract of fifteen acres for an
orchard and set out a few apple and pear trees. The
following year he completed the work, and the Mulkey
orchard of fifteen acres really marks the beginning of
Idaho's horticultural history. This orchard a few years
after it was planted furnished practically all the apples
used in Lewiston and the mining camps north of the
Salmon River. Pack trains carried them over the Mullan
road to the Montana settlements on the upper Missouri.
The "Idaho" pear, now recognized by horticulturists as
one of the standard varieties in all sections where pears
are grown, originated in the Mulkey orchard.*

Hawley, James. *History of Idaho: Gem of the Mountains.* Vol. 1.
Chicago: S.J. Clarke Publishing, 1920, 470.

1863: IDAHO'S FIRST BANKS

The Museum of Idaho, in its history of Idaho Falls, reports
that "Anderson Brothers Bank opened in 1865 as a private
bank in Eagle Rock, Idaho. This was the fourth bank in
the state. Two banks were opened in Lewiston in 1863

and one in Boise in 1864." After buying out John Proctor, John Brearley opened the first bank—known simply as John Brearley's Bank—at the urging of his wife, Lucinda, to handle the flow of gold through the town via the assay office to the mint in San Francisco. He was born in Hudson, Michigan, in 1841, his parents being early settlers of that state. In 1855, Brearley crossed the plains with an ox team and spent several years in Sacramento. In 1862, he moved to Elk City, where he successfully engaged in mining. He purchased the express business between that place and Lewiston, carrying the materials on horseback through the summer months, while in the winter he made the journey on snowshoes. Brearley became a partner in and, for a short time, president of the Lewiston National Bank, founded by William F. Kettenbach in August 1883. He died on August 4, 1883. The other bank to open in 1863 has never been identified. See "1862: Idaho's First Assay Office."

An Illustrated History of the State of Idaho. Chicago: Lewis Publishing Company, 1899, 331.

1863: IDAHO'S FIRST OFFICIAL GOVERNMENT DOCUMENT

Local residents finally heard that they were part of a new territory on March 22. William Wallace arrived in Lewiston

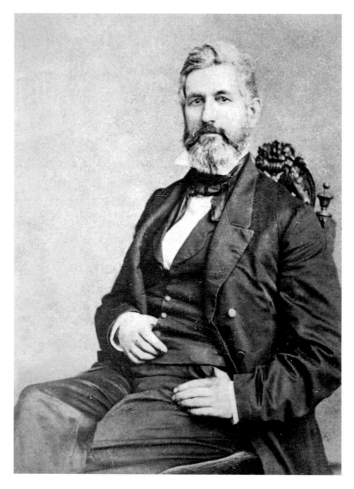

William H. Wallace.

on Friday, July 10, and did not waste any time getting to work as territorial governor. On Saturday, he set his pen to paper and wrote the following letter:

Lewiston, Idaho Territory
July 11, 1863

Wm. H. Seward
Secry. of State

Sir:
I have the honor to report that I reached this place last evening and this morning entered on the duties of my office. Any communication addressed to me at this place will be received.

Yours respectfully,
W.H. Wallace
Governor, Idaho Territory

Probably composed at the Luna House, the original letter was written on lined foolscap, paper measuring approximately thirteen by sixteen inches.

National Archives, Washington, D.C.

1863: IDAHO'S FIRST TERRITORIAL CAPITAL AND CAPITOL

Wallace personally selected Lewiston as the capital city. It seemed a good choice for several reasons. The town was the largest in the new territory and was the closest location to his residence in Steilacoom, Washington Territory. His temporary territorial secretary, Silas Cochran, advocated keeping Lewiston as the capital for the foreseeable future. The existence of a large pro-Confederacy element in other parts of the territory, particularly in present-day Montana and the Boise Basin, played a significant role in his advice to the governor. The second governor, Caleb Lyon, was suspected of having strong Southern sympathies. The new territory had four counties, twenty mining towns and twenty thousand people. Upon his arrival in July 1863, Wallace appropriated a building for use as an office and authorized the payment of $600 ($10,500 today) per year to the owner, Chester P. Coburn.

Constructed by his brother Albert as a livery store, the building did not serve in the role we expect of a capitol. The territorial legislature did not convene there. The building was primarily the governor's office and residence, much like an executive office building. Several state archival references to a "governor's mansion" can be found. However, the structure to which these comments refer did not exist in the 1860s. The architectural style of

Idaho territorial capitol/executive building, 1905.

the capitol is described as "false front" or Italianate. The vertical extension of the façade beyond the roofline created the vertical pattern to a gabled structure. Usually found on commercial properties, the style created a sense of order to new towns by standardizing the look of a street and hiding the ordinary lines of the buildings behind them. The capitol included faux columns. "Suitable for many different building materials and budgets, the Italianate remained...a common style for the construction of other buildings like barns, town halls, and libraries, in the United States until the 1870s."

Kenning, Kaleene. *San Francisco Architecture & Design Examiner.*

1863: IDAHO'S FIRST INAUGURAL ADDRESS

By the time the first Idaho territorial legislature met in December 1863, William Wallace had left the territory to serve as the delegate to Congress. William B. Daniels became acting governor, as provided in the provisions of the Organic Act. At 2:00 p.m. on December 9, Daniels was inaugurated with great ceremony. The official record states, "The approach of his excellency, the governor, was announced at the door; whereupon a passage was cleared by the sergeant-at-arms, and the governor, escorted by [a] committee [including Alonzo Leland] came into the Hall of Representatives." In his address, Daniels said, in part:

> *Shall Idaho, the largest of the territories, take her stand in sympathy with a cause* [slavery] *so vile, and cloud the morning of her existence with the darkness of treason? No, let her, as her name indicates, sit among the mountains, a gem of the brightest luster, radiant with unconditional loyalty, attracting by her glorious light the gaze and admiration of mankind.*

Brosnan, Cornelius J. *History of the State of Idaho*. New York: Charles Scribner's Sons, 1918, 188–89.

1864: IDAHO'S FIRST TRIAL

Proceedings began on January 19 against James Romain, David Renton and Christopher Lower for the murders of Lloyd Magruder, William Chalmers, Bill Phillips and Charlie Allen. Judge Samuel C. Parks officiated. The first jury had to be dismissed, as it had been chosen improperly. Defense attorneys argued that the court had no jurisdiction, as it was located on Nez Perce tribal land. Each defendant pleaded not guilty to the

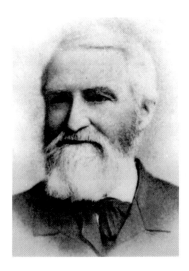

Samuel C. Parks.

charges. The prosecution's case focused on the testimony of Billy Page, who had been with the Magruder party at the time of the crime but had been spared by the defendants. By January 23, the jury had decided on a guilty verdict. The men were hanged on March 4 at the foot of the Thirteenth Street grade, near the present site of the St. Joseph Regional Medical Center offices (formerly the old Albertson's store). The trio was found guilty and executed even though Idaho Territory had no law against murder or any other crime at the time.

Williams, Bradley B. *Idaho's First Territorial Judges*. Ninth Judicial Circuit Historical Society, n.d.

1864: IDAHO'S FIRST U.S. ATTORNEY AND RESIDENT GOVERNMENT OFFICIAL

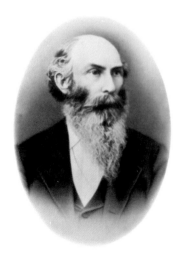

George C. Hough. *Courtesy of the Idaho State Historical Society.*

On February 29, 1864, George Campbell Hough, a Lewiston attorney, became Idaho's first U.S. attorney and the first resident of the territory to receive a government post. Nonresidents were common and disappointing officials. Hough had written to former governor Wallace, "Great God, can we not have judges from among ourselves or at least from Oregon, California or Washington, who understand us & can stay with us?" Hough would become a special Indian agent for the territory and was present at the Lapwai Council of 1867 during treaty negotiations with the Nez Perce. Hough referred to their leader, Chief Lawyer, as "the consummate

diplomat." He helped found the Idaho Union League to combat a strong Confederacy secessionist movement in Idaho during the Civil War.

Idaho State Historical Society. Reference Series #370. 1966.

1864: IDAHO'S FIRST TERRITORIAL PRISON
(BASED ON THE BEST EVIDENCE)

The jails at Lewiston and Idaho City served as the territorial prison locations until 1872, when the legislature provided permanent facilities. The prison buildings were completely inadequate to the task, constructed of rough logs overlaid with heavy, rough-sawn planking. The cells were small, dirty and cold. Little effort went into provisions for ventilation and lighting. The grand jury at Lewiston gave a hint in 1864 of conditions at the north Idaho branch of the prison: "The building rented for the County Jail [is] totally unfit for the purpose for which the same was intended nor does it appear to this Grand Jury that it has ever been a safe or proper place wherein to confine offenders against the law." North Idaho's sparse population and the fewer convictions in its courts led to few prisoners being housed at the Lewiston facility.

Idaho State Historical Society. Reference Series #252. 1964.

1864: IDAHO'S FIRST FEMALE PHOTOGRAPHER (BASED ON THE BEST EVIDENCE)

Amelia Ann Schwatka Strang was an Oregon pioneer who announced the opening of her new Lewiston studio on November 19:

> *PHOTOGRAPHING. The undersigned having opened a Daguerrian Room in Lewiston, is prepared to take all kids of Photographs, Ambrotypes, and Melainotypes, in the most superior style and at Reasonable Rates. Albums of every description always on hand. Room—On C Street, between 4th and 5th.*

In November 1865, she obtained a federal tax license for her Lewiston business, a feat very rare for a woman at the time. Indeed, she may have been the first in Idaho. She moved to Santa Cruz, California, for a short time with her husband, Thomas, and sons, Augustus and Frederick, in 1868 and became an important children's photographer. "No Lady need say she cannot get a picture of her baby, for Mrs. Strang is acknowledged to have no equal taking Children's Pictures." In 1869, she was awarded a patent for a new boot design. Strang's son Frederick died in October 1884 of a strangulated hernia while studying at the United States Naval Academy. The *Journal of the House*

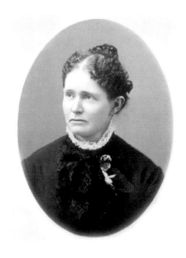

Amelia Strang.

of Representatives (December 1, 1884) reported that the hernia was the result of injuries from "cruelties practiced upon him by senior cadets." The secretary of the navy was ordered to investigate but found no grounds to support such claim. A disgruntled parent of a court-martialed student instigated the investigation. Strang's brother Frederick Schwatka served on the Arctic patrol that went in search of the Franklin Expedition and found the grave of Lieutenant John Irving. Amelia lived in San Francisco until 1879, when she moved to Salem, Oregon, where she died in 1899.

Palmquist, Peter E., and Thomas R. Kailbourn. *Pioneer Photographers of the Far West: A Biographical Dictionary, 1840–1865*. Stanford, CA: Stanford University Press, 2000, 25, 529–30.

1864: FIRST GRAPE ORCHARDS IN THE INLAND NORTHWEST

Most Lewiston residents know little of the important role that the city played in the state's wine industry in the fifty years prior to Idaho going "dry" in 1915. An article in the *Idaho Statesman* (September 5, 1865) reported that a vineyard of Royal Muscatine cuttings had been planted early in the spring of the previous year (1864), had survived the winter well and was beginning to produce grapes. That was the same year that the Napa Valley founded its wine industry. By 1906, more than fifty varieties of grapes were being grown in Lewiston vineyards.

A native of France, Robert Schleicher arrived in Lewiston in 1872 after leaving the U.S. Army. He worked as a clerk at the Hotel De France, moving to the Raymond House after it was built in 1879, as he was a friend of Raymond Saux. He purchased many lots in the area southwest of the courthouse and in 1880 filed a claim for 416 acres in east Lewiston. In 1883, he purchased land on the south side of the Clearwater, near the old Gurney town site (now Clearwater Paper Company). A small stream provided water to the fledgling vineyard, which had grown to about 80 acres by 1900. Schleicher became widely known and honored for his winemaking expertise, winning recognition with medals at the 1901 Buffalo Pan-American Exposition, the 1904 St. Louis World's Fair and the Lewis & Clark

Louis Delsol.

Exposition (Portland, 1905). He was the first vice-president of the newly formed Commercial Club in 1898. In 1905, he was quoted as saying, "My candid opinion is that this is the best place in the United States for grape growing as they do better here than any other fruit...There is no reason why it should not be the leading industry here." Schleicher wrote the chapter on winemaking that appeared for many years in the *Idaho Horticulture Manual*.

Born in Decazeville, France, Louis Delsol came to Lewiston in 1866 after mining in California and Oregon. He homesteaded a tract of land in east Lewiston, where Clearwater Paper Company is now located, and built a thirteen-room chateau-style stone house in 1878 that became a popular meeting place. His flower gardens were widely acclaimed. Delsol set up an experiment to test the soils in 1872 with grape cuttings he had imported. His cellars were reported to have been one hundred feet in length, excavated back into the hillside near the house. He retired from his agricultural ventures in 1901 and began investing in real estate. The Clearwater River at the time filled several sloughs near his home. The area was developed into a public park and opened in June 1904. Contrary to popular belief, Delsol Lane was named for his brother Justin, who maintained a farm in the neighborhood in the 1880s and 1890s. See "1935: Idaho's First Bonded Winery after the Repeal of Prohibition."

Idaho Wine Commission

Wing, Robert. *The History of Wine in Lewiston*. Lewiston, ID: Nez Perce County Historical Society, 1990.

1864: NORTH IDAHO'S FIRST EPISCOPALIAN CONGREGATION

On Christmas Day 1864, local Episcopalians met for their first services, presumably under the direction of Reverend J. Michael Fackler, who was the director of the Missionary District of Idaho and had only recently founded a congregation in Boise. As a consequence, the church was named the Church of the Nativity. Until 1881, it was served by itinerant

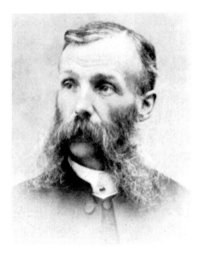

Reverend John D. McConkey. *Courtesy of the City of Portland, Oregon Archives.*

ministers. Reverend Lemuel Wells, rector of St. Paul's in Walla Walla, began making regular visits to Lewiston to conduct services in 1874.

In July 1881, John D. McConkey arrived and would serve the community for many years. He set himself to the task over the next ten years of acquiring property and building a proper church. The congregation had been meeting at the Masonic Lodge, the Universalist Church and the Red Cross

Hall. The Vollmer family was among the most notable early members. Lewiston businessman, judge and mayor George E. Erb recounted how McConkey had been his mentor and acted as his tutor for a few months, thus enabling him to satisfactorily pass an examination and secure a teacher's certificate. A new church finally opened for services in 1891 on Eleventh Street downtown. That building was moved to Eighth Street on Normal Hill in 1920 using horses and steam winches. McConkey was instrumental in the establishment and operation of Wilbur College in 1882. He was also active in the Knights of Pythias and was a city magistrate. McConkey died in 1913.

Episcopal Diocese of Idaho

1865: NORTH IDAHO'S FIRST FIRE DEPARTMENT

The *North Idaho Radiator* (January 25, 1865) and the *Washington Statesman* (March 3, 1865) reported that a volunteer fire department had been formed in the city and was known as Hook and Ladder Company No. 1. The first major fire in the city occurred on February 2, 1868, when nine buildings were destroyed, including the Globe Hotel, Norton and Bunker's Saloon and the California Bakery. By 1884, Lewiston had enacted regulations forbidding wooden buildings from being built in key areas of town because of

Hook and Ladder Cart No. 2, November 1909.

fire hazards. The city installed a steamboat bell in the fire station on Third Street in April 1884, after a large blaze destroyed many buildings in November 1883. In 1907, the bell was placed in Pioneer Park. Until 1928, a bell master rang the device, using the number of rings to indicate where in the city the fire was located. City Ordinance 120 formalized the fire department in August 1891. Lewiston began paying firemen for their services in 1910.

1865: IDAHO'S FIRST JEWISH CHILD

Born on July 7, Leah Grostein was the daughter of Robert and Rosa Grostein. She married Aaron Kuhn on May 8, 1884, making her the first Jewish bride in

Idaho. A German immigrant and Colfax, Washington businessman, Aaron would became the president of the Spokane & Eastern Trust Company, which was eventually acquired by Seafirst and then Bank of America. In August 1897, Leah was the first woman to drive up and down the steep and precipitous Salmon River Grade on the road to Florence, Idaho. The feat was accomplished without brakes on the buggy. Soon after their move to Spokane, Washington, from Colfax in 1902, she opened a special sewing school for underprivileged local girls ages six to fourteen. Aaron and Leah were frequent world travelers and attended the coronation of George V of England on June 22, 1911.

"Immigration & Emigration." Digital Atlas of Idaho. Idaho State University.

1866: IDAHO'S FIRST ATTORNEY ADMITTED TO THE BAR

Born in Virginia, Hartwell Lytton Preston is believed to have been educated at Harvard and was active in the antislavery movement and the Underground Railroad, traveling as a Free-Soil lecturer. Preston came to Idaho in 1866 and was admitted to the bar in Lewiston on May 31 by the newly formed Territorial Supreme Court. In

1875, while working as an attorney and judge, he married Emily Burke, a prominent California faith-healer, and the two formed the town of Preston as a religious retreat in Sonoma County. The couple invited others to join them in "living religion." Popularly know as the Religion of Inspiration, its members called themselves "Volunteers of God" or "Covenanters." Although

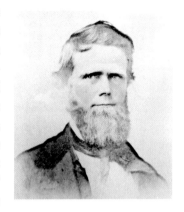

Hartwell Lytton Preston, circa 1865. *Courtesy of the Healdsburg Museum and Historical Society.*

attorneys had been permitted to practice in the territory as early as February 25, 1864, when several were admitted by Judge Parks in Idaho City, Preston was the first to be sworn in by the Supreme Court.

Kristensen, Debora K. "The First 50 Men in Idaho Law." *The Advocate*, October 2010, 55–56.

LeBaron, Gaye. "Little Is Left of 19th Century 'Heaven on Earth.'" *Press Democrat*, 1988.

1867: NORTH IDAHO'S FIRST ROMAN CATHOLIC PARISH

Father Joseph M. Cataldo. *Courtesy of Boise State University.*

Father Joseph M. Cataldo first visited Lewiston in 1866, the year after his arrival at the mission now named for him near Coeur d'Alene, Idaho. In 1867, he returned to found the Lewiston parish—St. Stanislaus—and several missions nearby. In 1868, he built a small church and residence on private property in order to circumvent the ban on permanent structures on tribal land. In 1886, a second church was constructed on Fifth Street between Main and C (now Capital) Streets under the guidance of Father Alexander Diomedi, the first resident priest (1883). The St. Aloysius School for boys opened in August 1884 under the direction of Father Diomedi and stood next to the old St. Stanislaus Church. Staffed by the Sisters of St. Francis of Newcastle, Minnesota, the school had an enrollment of forty to fifty students who paid tuition of twenty dollars a

month. The operation was plagued by a lack of teachers and finally closed in 1893. The Sisters of Visitation purchased a plot of land in January 1896 and contracted the services of Lewiston builder Harry Madgwick to construct a school for girls southeast of the old cemetery grounds. Called the "Visitation Academy," the brick building was the second large structure to arise on Normal Hill, after the Normal School (1895). A new Roman Catholic church rose next to St. Joseph's Hospital in 1905. The bell at the present church came from the building on Fifth Street. The academy became St. Stanislaus School under the direction of the Sisters of St. Joseph and was destroyed by fire on November 3, 1935.

Bradley, Cyprian, and Edward Kelley. *History of the Diocese of Boise, 1863–1953*. Caldwell, ID: Caxton Printers, 1953, 271.

1869: NORTH IDAHO'S FIRST GOVERNMENT LAND OFFICE

The General Land Office (GLO) is an agency of the United States government responsible for public domain lands, as surveyed from the "Beginning Point," a monument at the border between Ohio and Pennsylvania. The office was placed in the Department of the Interior when that

agency was formed in 1849. The creation of the Boise Meridian in April 1867 permitted the GLO to survey the entire territory with accuracy. The first Lewiston registrar, Stephen S. Fenn, was appointed on July 16, 1867. The first plat was filed at the Lewiston office on October 23, 1869. In 1871, Charles Thatcher, who founded one of Lewiston's oldest surviving businesses, was the first local resident to file for rights to property within the city limits. The land office closed in 1925.

McConnell, William J. *Early History of Idaho*. Caldwell, ID: Caxton Printers, 1913, 353.

Sims, Cort. *A Land Office Business: Homesteading in North Idaho*. Coeur d'Alene: Idaho Panhandle National Forest, 2003, 20.

1873: IDAHO'S FIRST PRESBYTERIAN CONGREGATION

According to *Hall's Index of American Presbyterian Congregations*, the Indian Mission Presbyterian Church in Lewiston was first reported in 1873 by the Presbytery of Oregon, having been formed on March 14. However, the parishioners had no building of their own. Only seven men and women made up the first group. The congregation disbanded in 1874 after the first minister, Reverend W.J. Monteith, was forced to retire because of ill health. In 1877, the First

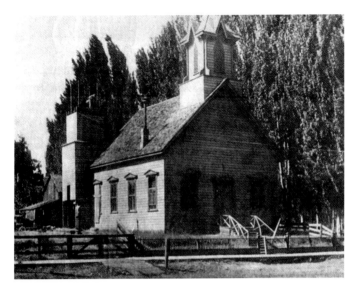

Presbyterian Church, Main Street, circa 1890.

Presbyterian Church in Lewiston was reported by the Presbytery of Oregon. T.M. Boyd became pastor in 1879 and, with Monteith's son, spearheaded a campaign to finance the construction of a church. On April 21, 1881, the task was completed with the dedication of the new building, which stood in the 1000 block of Main Street near the schoolhouse. Much of the money to complete and fit out the church was raised from the performances of a play. In 1920, the congregation moved to Normal Hill, next to Lewiston State Normal School. A fire broke out on May 14, 1930, under the roof of the East End Furniture

Company, which was then using the old building. The resulting blaze destroyed the structure, its contents and a house next door. In 1944, the congregation changed its name to the Federated Presbyterian Church. In 1951, it became the Congregational-Presbyterian Church. See "1881: Idaho's First Legitimate Theater."

1874: NORTH IDAHO'S FIRST TELEGRAPH SERVICE

John Vollmer ran a telegraph line into Lewiston as a private business venture to communicate with his interests in Walla Walla and for five years capitalized on communication with the technology. In June 1879, the first message was sent to Dayton, Washington Territory, from the newly opened public telegraph office. The wire was a branch of the main military line, built to connect Dayton with Fort Lapwai. The citizens of Lewiston subsidized the enterprise with a free office in the town and several hundred poles, with the understanding that they might use the line when not in use by the military. The following was the first telegram sent from Lewiston:

> *Lewiston, I.T., June 17, 1879, 5pm*
> *To the Mayor and Citizens of Dayton, W.T.*

Greetings,

The people of Lewiston are happy to announce to you by way of first telegram over the first U.S. Government line yet established north of San Diego, California, that they hold sacred in this manner this the anniversary of the struggle of our forefathers on Bunker Hill.

The telegram was signed by many of Lewiston's leading citizens, including William F. Kettenbach, John Vollmer, Alonzo Leland and Hazen Squier. See "1878: First Telephone Call on the Pacific Coast."

An Illustrated History of the State of Idaho. Chicago: Lewis Publishing Company, 1899, 313.

French, Hiram S. *History of Idaho.* Vol. 3. Chicago: Lewis Publishing Company, 1914, 1007.

1877: IDAHO'S FIRST UNIVERSALIST CHURCH CONGREGATION

While the local Roman Catholic congregation had formed in 1867 and the city had several Protestant groups served by circuit pastors, the Universalist Church was the first to erect a building for worship in 1879, two years after the founding of the congregation, which included Dr. Madison Kelly and Edmund Pearcy, operator of the ferry a mile south

of the confluence of the Snake and Clearwater Rivers. The local Episcopalian congregation used the building for several years before constructing its own church. By 1901, the Universalist group had disbanded and gone into receivership. The General Convention of the church sued the congregation's governing body, saying that it had improperly managed the building, allowing it to be used for other purposes, most notably as the meeting hall for the Rutherford B. Hayes Post #2 of the Grand Army of the Republic, the first in North Idaho. The General Convention prevailed in *Madison, et al v. Steele* (9 Idaho 141). In 1961, the convention consolidated with the American Unitarian Association to form the Unitarian Universalist Association. In 1984, a local congregation was reestablished.

Unitarian Universalist Association of Congregations

1878: FIRST TELEPHONE CALL
ON THE PACIFIC COAST

John P. Vollmer made the first telephone call on the Pacific Coast from his home on old E Street (Snake River Avenue) to his business at Fourth and Main Street on May 10. He had seen a demonstration of the new device in San Francisco. There were three devices in Vollmer's exchange. The first commercial telephone used by Alexander Graham Bell was

based on his patent of January 1877. The telephone consisted of a single transmitter/ receiver placed within a rectangular wooden box. One would speak into the opening in the box and then listen through the same opening. Two or more of these box phones were connected in series on a line with a ground return. The first telephone line was installed in April 1877 between Charles William's electrical shop on Court Street, Boston, and his home about three miles away. One month later, the first rented installations were completed, making this line the nation's first commercial telephone

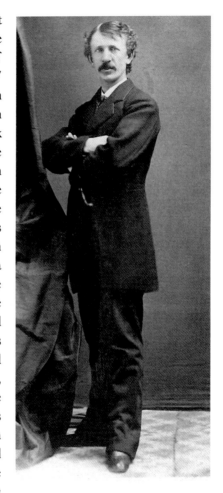

John P. Vollmer, circa 1875. *Courtesy of the John P. Vollmer Family Archives.*

service. The early box phones had no signaling devices to alert people to incoming calls. In June 1877, Thomas Watson devised a "thumper" that would strike the diaphragm of the box phone to make a tapping sound on the receiving telephone as a signal device.

Hart, Arthur. "Hello, Girls." *Idaho Magazine* (May 2006), 64. *New York Times*, May 10, 1917.

1878: NORTH IDAHO'S FIRST PUBLIC LIBRARY (BASED ON THE BEST EVIDENCE)

Until only recently, the yeoman work of the Tsceminicum Club to open the Carnegie Library in April 1905 obscured the efforts of the Lewiston Library Association, formed in the late 1870s. The association maintained, advertised and operated a public lending library. Primary documentation points to Lewiston's having North Idaho's first public library immediately after the Nez Perce War through the efforts of a reading group that had grown into the library association. The first identified location of its "reading room" was on the second floor of the general store owned by James Flanagan. Charles G. Kress was the president of the association, with William H. Denny as librarian. The *Lewiston Teller*, on January 26, 1878, wrote, "Our citizens should see to it that the library room should be well supplied

with reading matter, and kept open as a place of resort for our young people where they can make mental progress and be directed from those influences that are demoralizing." Many civic leaders—including John Vollmer, Charles Thatcher and Joseph Alexander—donated books and magazines. Several fundraisers were held, one of which raised more than $1,200 (2012 value). By the spring of 1879, government documents were available at the library.

Based on the identities of patrons, the Carnegie Library can be identified as a legacy of local library operations predating it by a quarter century. It should be noted that on May 6, 1895, the "public library association" petitioned the city council, asking that a suitable lot be set aside for its building at such time as it was prepared to undertake the work. The council unanimously agreed to donate the lot when the time came. See "1900: Idaho's First Professional Town Librarian" and "1905: Idaho's First Carnegie Library."

Lewiston Teller, January 12, 1878; January 26, 1878; February 2, 1878; March 2, 1878; March 9, 1878; January 17, 1879, April 11, 1879.

Report of the Commissioner of Education for the Year 1884–1885. Washington, D.C.: Government Printing Office, 1886, 701.

1879: NORTH IDAHO'S FIRST WEATHER STATION

From 1879 to 1885, the Army Signal Corps recorded weather data in Lewiston. Three observations were taken and recorded each day for barometric pressure, maximum and minimum temperatures, dew point and relative humidity, all of which were submitted by mail every month for compilation. The station recorded the longest period without measurable precipitation in Lewiston: ninety-two days, ending on September 4, 1883. Clayton Butler, a longtime Lewiston druggist, came to Lewiston in 1883 as a Signal Corps sergeant, weather observer and telegrapher. From 1885 to 1900, Lewiston's weather reports were the work of local observers, the first of which was orchardist Robert Schleicher. In October 1900, the Department of Agriculture opened a weather bureau, which was housed by 1904 in a rented building at 312 Prospect Boulevard and for which the government paid a rent of $45 ($1,100 today) per month. Weather forecasts were signaled by means of flags hoisted up a nearby pole overlooking Lewiston's business district. After the opening of the federal post office in 1912, the bureau transferred its office to the new building until 1933, when the office was closed upon the retirement of Walter W. Thomas, who had been Lewiston's meteorologist since 1907. Again, local observers would take over duties of

reporting the weather until July 1946, when a bureau opened at the new Lewiston–Nez Perce County Airport. The office was finally closed in 1997. See "1864: First Grape Orchards in the Inland Northwest."

Annual Report of the Chief Signal Officer. United States Army, to the Secretary of War (1882), 15, 180, 192.

1880: IDAHO'S FIRST CHARTERED PUBLIC SCHOOL DISTRICT

The school year was anything but regular in Lewiston's early days. An itinerant teacher would arrive, advertise for students, hold classes and leave after just two or three months. The town's first school opened in 1863 in a log building at Third and Capital Streets. With wide cracks in the walls, the structure depended on crude wood-burning stoves for heat, and the only light was from the sun. The first blackboard and chalk were not used until 1867. By 1871, concerned citizens had agitated for the construction of a proper schoolhouse. A special tax was levied to raise the funds, estimated to be $1,450 ($26,000 today). The levy fell well short of the final cost. So a group of parents sponsored a "town ball" in a local saloon converted into a public hall. The gala event was a social success, raising several hundred dollars. The

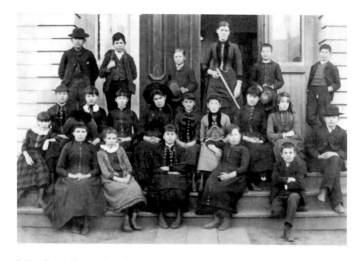

Miss Cornelius and students, Lewiston Public School, circa 1888.

resulting building opened in 1872 at Tenth and Main Streets, with Miss Nancy Simmons as the lone teacher, and was praised as the "best school building in Idaho." Students and teachers finally completed their first nine-month school year in 1878–79. Then, on December 30, 1880, the eleventh Idaho territorial legislature chartered Lewiston as Idaho's first public school district. From 1881 onward, the school was graded, but it would be awhile before every student received textbooks, which had been introduced in 1879. The schoolhouse was soon too small, and the structure was replaced in 1882 by a stately three-story structure that stood until 1939. See "1881: Idaho's First Election Allowing Woman to Both

Vote and Stand for Office" and "1888: North Idaho's First High School."

The Illustrated History of North Idaho. San Francisco: Western Historical Publishing Company, 1903, 116.

1881: NORTH IDAHO'S FIRST LEGITIMATE THEATER (BASED ON THE BEST EVIDENCE)

When the Nez Perce War erupted in 1877, Grostein and Binnard's building on the corner of Second and Main Streets was Lewiston's strongest and was set aside

Grostein & Binnard building, circa 1900.

for women and children if the city were attacked. In 1881, the partners decided to convert the rooms on the second floor into a theater. The first production was a lavish biblical play called *Queen Esther*. Directed by local Presbyterian minister T.M. Boyd, the congregation's amateur cast lacked proper costumes. Boyd convinced the Masonic Lodge to lend its ceremonial robes for the duration of the play, which ran for two weeks and even "went on the road" to Pomeroy, Washington. The proceeds helped complete their new church on Main Street. From January to June 1896, the second floor of the building housed the first classes of Lewiston State Normal School. Until the construction of the Temple Theater in 1904, the Grand Theater Opera House held a monopoly on stage performances, which included many traveling professional troupes. Abraham Binnard's son Isaac managed the Temple Theater and opened the Liberty Theater in September 1921. See "1862: Idaho's First Jewish Permanent Resident."

Yates, Kristine M. "Co-Existence and War Between the Temples and Grand Opera Houses during Lewiston, Idaho's Theatre Boom." In *Northwest Theater Review*, Vol. I. Corvallis: Oregon State University, 1993, 19.

1881: Idaho's First Election Allowing Women to Both Vote and Stand for Office

When the territorial legislature chartered Lewiston's school district, the bill specified "a board of school commissioners consisting of five competent citizens to be elected by the citizens." Women were expressly entitled to vote at school elections and run for office. Several states had granted women the right to vote in school elections in the 1870s. Boston had elected the first woman to a school board in 1873. Lewiston would now test its own sense of equality. Two women—Mrs. John P. (Sarah) Vollmer and Mrs. James W. (Fannie) Poe—were among the ten people who filed for the seats.

Sarah Vollmer, circa 1885. *Courtesy of the John P. Vollmer Family Archives.*

Both women lost in the election held on May 18, 1881. The *Lewiston Teller* commented, "A goodly number of our people

could not be made to see the propriety of placing women upon the ticket as candidates to decide questions which must come up before the directors in relation to school finances." Women were acceptable for "their softening and healthy influence" on children, but they were not fit, so many thought, to be the judges of how public money should be spent. Of 186 votes cast, 30 came from local women. Mrs. Vollmer and Mrs. Poe garnered 66 and 68 votes, respectively. More men than women supported the two female candidates. The *Teller* concluded that "our people were aroused at some degree at least to the importance of having good schools, even if the women question did rouse them."

Long-identified with the education of Lewiston's children, Vollmer helped organize the charity ball to raise money to complete a new schoolhouse in 1872. Idaho would not grant women the right to the vote until a constitutional amendment passed in 1896. See "1880: Idaho's First Public School District."

1881: IDAHO'S FIRST AND THE OLDEST CONTINUALLY OPERATED GUN CLUB IN THE UNITED STATES

Although several locations were used by enthusiasts, including a range at the base of what is now Eleventh Avenue where it joins Snake River Avenue, the Lewiston

Gun Club's first permanent facility seems to have been just off Lindsay Creek Road, at the base of what is still called "Old Gun Club." The first clay targets were introduced in the United States in the 1880s. The group moved to Holbrook Island, in the Clearwater River, for several years before establishing a range near the old Speer plant near the Snake River in the 1940s. In 1964, the club opened its trap at the Lewiston Airport, with fifteen houses built by volunteers. At its height, the club had more than three hundred members. The club lost its lease in 2008 but has remained active by using facilities in nearby towns, notably Colton, Washington and Culdesac, Idaho.

Lewiston Morning Tribune, July 1, 1903, 8.

1882: IDAHO'S FIRST INSTITUTION OF HIGHER LEARNING

The Lewis Collegiate Institute was established in 1882 and held classes at the Methodist-Episcopal church on Eleventh Street in downtown Lewiston. On March 5, 1883, the city council accepted the bid of $25 ($570 today) per acre from the institute for land "lying on the plateau south of the business portion of the City." The territorial legislature approved a charter to "improve the corporation" on February 4, 1885, and elevated the school's status. By the

terms of the legislative bill, when the school graduated its first class, which records indicate was on June 15, 1885, it became "a college or institution of higher learning," at which time it became Wilbur College. The *Executive Documents of the 49th Congress* (1886) lists the college as the only one for "normal [teacher] training" in the Idaho Territory and the only site for "advanced instruction," with ninety-one students attending. Its library had one thousand volumes, with its property worth $20,000 ($470,000 today). Trustees of the new college, which operated under the sponsorship of the church, included John Vollmer. Sarah E. Poe, later a faculty member at the University of Idaho, was a graduate.

The school was empowered to "confer degrees and other testimonials of literary and scientific distinction." It had its detractors. In September 1885, Leroy T. Weeks was hired to teach Greek and Latin at the school. In his autobiography, he stated that he was very dissatisfied with the institution, labeling it "a play-school in a fence corner." Weeks did not stay long, moving on to missionary work.

Adkinson, John. *Centennial History of American Methodism.* Vol. 3. New York: Phillips & Hunt, 1884, 536.

Report of the Commissioner of Education for the Year 1882–1883. Washington, D.C.: Government Printing Office, 1884, 818.

1883: NORTH IDAHO'S FIRST CHARTERED NATIONAL BANK

Chartered on June 11, 1883, the First National Bank of Lewiston had its offices at the west end of the Vollmer Building until 1904, when the bank moved to the east end of the structure. The bank remained there until 1946, when the firm was purchased by First Security Bank of Idaho. The old bank was very successful under Vollmer's leadership. A 1903 report stated:

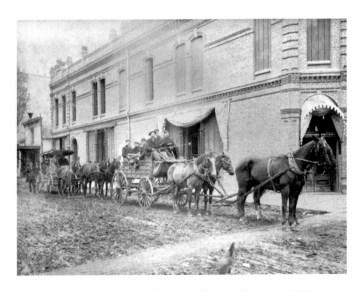

Vollmer Great Bargain Store—Lewiston National Bank, circa 1888.

Business was begun on a capital of fifty thousand dollars [$1.2 million today], *and now there is a surplus of that amount, with ninety-two thousand dollars* [$2.1 million today] *undivided profits and a reserve fund of forty-five thousand dollars* [$1.04 million]. *In its dividends it has returned the capital to the stockholders and thirty per cent additional, and it stands thirty-fourth on the roll of honor of the thirty-three hundred national banks of the United States.*

The Illustrated History of North Idaho. San Francisco: Western Historical Publishing Company, 1903, 138.

1883: IDAHO'S FIRST WOMAN'S CHRISTIAN TEMPERANCE UNION CHAPTER

Francena Kellogg Buck was a pioneering woman. The first female bookkeeper in Chicago, she worked for Potter Palmer, who was instrumental for much of the development of the historic State Street section of the city. Buck was one of the first female graduates of a classical course of study from an American college (Lawrence, 1857). When her husband, Norman, enlisted to fight in the Civil War, she became a nurse and served in Nashville, Tennessee. She was cited in dispatches for her exemplary role at the

military hospital. In 1880, Norman was appointed to the Idaho Territorial Supreme Court. She arrived in Lewiston in 1882 and helped organize the temperance societies associated with several of the local churches, with the result being the first Woman's Christian Temperance Union chapter in the Idaho Territory. She was elected president

Francena Buck.

of the North Idaho WCTU in 1883. She also was passionate about women's suffrage. She died in 1925 at the age of ninety.

De Sware Gifford, Carolyn. *Let Something Good Be Said: Speeches and Writings of Frances E. Willard.* Champaign: University of Illinois Press, 2007, 64.
Spokane Daily Chronicle, July 1, 1913, 2.

1884: IDAHO'S FIRST RESIDENT DETAINED UNDER THE PROVISIONS OF THE CHINESE EXCLUSION ACT (BASED ON THE BEST EVIDENCE)

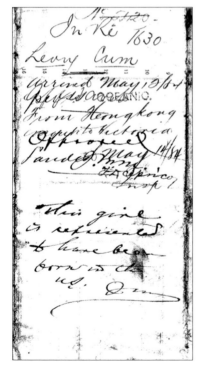

Immigration file cover for Leong Cum. *Courtesy of the National Archives and Records Administration.*

Immigration officials were very suspicious of Chinese women seeking to enter the United States, routinely suspecting them of being prostitutes. One of the first women to apply for admission through the port of San Francisco after the passage of the Chinese Exclusion Act (1882) was Leong Cum. In 1873, she had traveled to China with her mother and stayed for nearly eleven years. Her mother returned to the United States in 1876 and began working in San Francisco. On May 12, 1884, Leong Cum

arrived aboard the steamer SS *Oceanic* to join her mother and found it necessary to distinguish herself from "less desirable female applicants." As no detention government centers were yet available, men were kept aboard ships in the bay. Women traveling alone were often sent to one of the mission homes in San Francisco, such as the Chinese Presbyterian Mission Home, which had been established to "rescue" Chinese prostitutes. Leong's mother was a garment maker by profession and had the foresight to prepare three affidavits for the immigration officers. The depositions verified that Leong Cum was a United States citizen born in Lewiston, Idaho Territory, in 1868. Her mother knew of the possible complications from the new law. According to a deposition dated July 9, 1883, her husband was still living and working in Lewiston. The documents note that she was "a woman of excellent reputation and irreproachable character." One of the testimonials came from Jerome Millian, an interpreter at the immigration center, who was "well acquainted with the Chinese community." Sixteen-year-old Cum was released and admitted two days later.

Barde, Robert, William Greene and Daniel Nealand. *The EARS Have It. Spotlight on NARA*. San Francisco: National Archives and Records Administration, Fall 2003, 2.

Chan, Sucheng. *Chinese American Transnationalism: The Flow of People, Resources and Ideas Between China and America during the Exclusion Era*. Philadelphia: Temple University Press, 2005, 17.

Lee, Erika. *At America's Gates: Chinese Immigration During the Exclusion Era, 1882–1943*. Chapel Hill: University of North Carolina Press, 2007, 135.

1885: IDAHO'S FIRST
REBEKAH DEGREE LODGE

The Daughters of Rebekah, also known as the Rebekahs and the International Association of Rebekah Assemblies, is an international service-oriented organization and a branch of the Independent Order of Odd Fellows (IOOF). Grand Master Augustus L. Simondi, who was by trade an assayer and banker in Silver City, Idaho, came to Lewiston and authorized the formation of the first Rebekah Degree Lodge in the Idaho Territory—Alpha Rebekah Lodge #1—on June 16, 1885, at the old IOOF headquarters on Main Street. By the advent of statehood in July 1890, there were fifteen lodges in Idaho. The Lewiston IOOF Lodge had been chartered in 1881.

McKillop, Walker & Co.'s Mercantile Register of Reliable Banks and Attorneys. New York, 1883, 24.
Rebekah Assembly of Idaho

1888: NORTH IDAHO'S FIRST HIGH SCHOOL

In March 1888, the older students at the public school walked out in protest when their teacher was fired and formed a new school of their own. After several years of offering a high school curriculum without an official diploma, the school board responded by creating a formal Lewiston High School, Idaho's second and North Idaho's first, and hiring a high school principal, Charles A. Foresman, who would later become state superintendent of public instruction. An additional building (the original Whitman School) was constructed in 1898, and in 1899 Lewiston hired its first full-time superintendent, Robert N. Wright, who added a third year to the high school curriculum. The class of 1900 chose purple and gold for the school's colors. The high school remained at its Main Street site until 1904, when a new building and campus opened on Normal Hill, and a fourth year was added to the course of study. By 1907, Lewiston's total school population had risen to 1,300. The district added Garfield School in 1910 and Lewiston Orchards School in 1912. When enrollment at the high school reached 200 in 1909, the Normal Hill building was nearing its capacity, creating the need for a larger structure, which was completed in 1914. The 1904 building became the original Webster School. By the mid-1920s, the district required a new, larger high school, which opened in March

Lewiston High School, circa 1905. *Courtesy of the Lewiston High School Archives.*

1928. In the following years, the district erected two junior high schools and seven elementary schools. See "1914: Idaho's First School District to Adopt the 6-3-3 Plan and Open a Junior High School."

Branting, Steven. "A Most Unusual Spring Break." *Golden Age* 30, no. 1 (2010): 5–8.

1888: IDAHO'S FIRST MILLIONAIRE
(BASED ON THE BEST EVIDENCE)

Born in Germany in January 1847, Vollmer immigrated with his parents and grandparents to Indianapolis, Indiana. After service in the Civil War, he traveled to California via the Isthmus of Panama, settling in Walla Walla, Washington. He moved to Lewiston in 1870 and purchased a home on what is now known as Snake River Avenue. Vollmer held controlling interest in the Lewiston Water and Light Company. His banking projects were numerous, and he amassed a huge fortune as a result of regional and national instability in the financial markets. Records show that he acquired much of his thirty-two thousand acres in holdings after foreclosing on owners during the "boom and bust" times from 1880 to 1900. He served as a state agent for the Northern Pacific Railroad, thereby controlling where spur lines would be built. This

John P. Vollmer, 1903.

led to him naming at least two towns after himself. The citizens of one (now Troy, Idaho) rebelled in 1897 and put the name to a public vote. Vollmer lost. In 1887, he organized the Idaho Transit Company to pursue the construction of a rail line from Lewiston to the Camas Prairie via a route south, but the enterprise was abandoned. Vollmer's other railway efforts were rewarded in September 1898 when the Northern Pacific Railroad completed a branch line to Lewiston. Vollmer died in 1917. See "1883: North Idaho's First Chartered National Bank."

Hill, Kristin E. *The Ultimate Idaho Atlas and Travel Encyclopedia.* Helena, MT: Riverbend Publishing, 2005, 114.

Pullman-Moscow Daily News, May 14, 1988, 13.

San Francisco Call, July 27, 1909, 11.

An Illustrated History of the State of Idaho. Chicago: Lewis Publishing Company, 1899, 312.

1892: IDAHO'S FIRST TRUST COMPANY

The Idaho Trust Company was a spinoff of the Lewiston National Bank, founded in 1883 by William F. Kettenbach and John Brearley. As noted earlier, Brearley was elected the first president but died soon after. Kettenbach assumed the position and held it until his death in September 1891. The trust company was incorporated with a capital stock of $50,000 ($1.1 million today). In 1898, Kettenbach's son took the reins of the company, becoming the

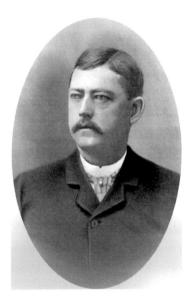

William Kettenbach, circa 1890. *Courtesy of the City of Portland, Oregon Archives.*

youngest bank president in the United States at the time. In the early twentieth century, the company would become embroiled in a scandal over the sale of public lands. Famed architect Kirtland Cutter designed the new building to house the company offices, a structure now known as Town Square, at Fifth and Main Streets.

Hawley, James. *History of Idaho: Gem of the Mountains*. Vol. 1. Chicago: S.J. Clarke Publishing, 1920, 400.

1893: IDAHO'S FIRST KINDERGARTEN

Millicent D. Pope rented a room in the old Methodist Church on Eleventh Street, on what was called "Piety Corner," in the fall of 1893 and enrolled ten students, including John Penn Fix, Katherine Fix, David Eaves, Anna Eaves and the son of George H. Lake, a local jeweler. Millicent set up the room with little chairs; a low, long table; and some blocks and other toys. Only twenty-one years old, she had run a kindergarten in Woodstock, Minnesota, before moving to Lewiston. The school was not a financial success and was not continued the next year. When interviewed on her eighty-ninth birthday in 1961, Millicent recounted how she used love for the little children and a desire to work and play with them rather than the educational theory that later became the accepted practice. Reference guide #882, Idaho State Historical Society (ISHS), states that the first kindergarten was opened in Boise about the same time. However, #882 has no citations or other documentary proof, and no ISHS historians can verify the accuracy of the research.

Lewiston Morning Tribune, October 26, 1961, 12.

1895: IDAHO'S FIRST WOMAN
ADMITTED TO THE BAR

At the time of Helen Louise Nichols Young's application, Idaho statutes limited the admission of attorneys in Idaho to "white males." Nonetheless, on October 26, 1895, the Idaho Supreme Court, composed of Chief Justice John T. Morgan (himself a member of the Constitutional Convention), Justice Isaac N. Sullivan and Justice Joseph W. Huston, convened in Lewiston and wrote the following:

> *In the matter of the examination and admission of Helen L. Young as an Attorney and Counselor of this Court:*
> *The above named applicant having made application for an examination in due form to test her legal qualification as to learning and ability as a prerequisite to admission to practice as an attorney and counselor in the Courts of this State, and having passed such examination to the satisfaction of the Court, and produced satisfactory testimonials that she is a woman of good moral character,*
> *Now, therefore it is ordered that Helen L. Young be and she is hereby admitted to practice as an Attorney and Counselor in all the Courts of this State.*

At the direction of the court, the clerk administered the required attorney's oath to Young and had her sign the Roll

of Attorneys. By September 1906, she had been engaged in the study of Christian Science long enough to qualify as a "practitioner." A practitioner is someone who has had systematic teaching in Christian Science (called Primary Class Instruction) and, for a modest fee, uses that training to "practice purely spiritual healing." Young worked as a Christian Science practitioner in Manhattan from 1906 until October 1915. She moved to Butte, Montana, and continued her work as a practitioner of Christian Science until her return to Manhattan in March 1918. She died there in 1951.

Kristensen, Debora K. *First 50 Women in Idaho Law.* Idaho State Bar Association, 2005, 1–4.

1896: NORTH IDAHO'S FIRST SALVATION ARMY POST

Ensign Shea and Lieutenant Morris, together with a musical group called The Crusaders, traveled from Spokane in 1895 in hopes of establishing a new Salvation Army post in Lewiston. In an article for the *War Cry*, the army's magazine, the two recounted the excitement of their trip down the Lewiston Hill by stagecoach and their first visit to town. The Crusaders had arrived the day before and hired a hall, using it as their dormitory for the night. Shea

and Morris made it to the city the following night, sharing the coach with the Crusaders' musical instruments. In their account, they related:

> *The boys sold* War Cries, *and the newsmen gave us a big sendoff, so we went to work. We visited all the homes and business houses, including the saloons, fourteen of them. At our open air meeting in front of the Silver Dollar Saloon, one man came out and joined us. He also stayed with us during our Saturday march down the street and sang with us. We were able to add four more to our collection of saved ones, collected eleven dollars, and had a record drown on Sunday night. The proprietor of the saloon said he would pay the rent on the hall if we would return the next month.*

Captain Lydia Burton and Lieutenant Jesse Long opened a headquarters on Main Street on May 26, 1896, in the basement of an old wooden building. The Salvation Army was in Lewiston to stay. The congregation moved frequently from one rented space to another until 1920, when it acquired its first permanent headquarters, a building on Fourth Street. In 2012, the church occupied the former Our Lady of Lourdes Church.

Lewiston Morning Tribune, August 13, 1961, 1.

1897: ONLY POPULIST PARTY U.S. SENATOR FROM A WESTERN STATE

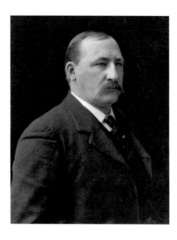

Henry Heitfeld, circa 1897. *From Autobiographies and Portraits of the President, Cabinet, Supreme Court and the Fifty-fifth Congress, Volume 1.*

Educated in St. Louis, Henry A. Heitfeld came to Lewiston in 1883 and engaged in stock raising. By the end of the 1890s, Idaho's politics had turned "populist," opposed to control by banks, railroads, trusts and the gold standard. Heitfeld served in the Idaho state senate from 1894 to 1897. The election of 1896 swept both Republicans and Democrats from major positions in local, state and national offices, and Heitfeld was appointed to the U.S. Senate by the Idaho legislature. On March 4, 1897, he was certified as a United States senator to the Fifty-fifth Congress, the only Lewiston resident to hold the office. Only six men were ever elected as senators on the Populist ticket. He did not seek reelection in 1902. He was a candidate for governor of Idaho in 1904 but was defeated by Republican Frank R. Gooding. The following year, Heitfeld became

mayor of Lewiston, serving until 1909. From 1914 to 1922, he was a registrar of the United States Land Office at Lewiston and was a Nez Perce County commissioner. The Heitfeld home is now the Lions Club on Eighth Avenue. He died in 1938 and was buried in Normal Hill Cemetery.

Biographical Dictionary of the United States Congress

1897: IDAHO'S FIRST ALL-FEMALE JURY
(BASED ON THE BEST EVIDENCE)

Frances Wood of Boise is said to have been Idaho's first female juror in 1897, but Lewiston holds the distinction of having the first all-female jury the same year. The jurors were Mrs. Emma Sullivan, Mrs. John (Lucinda) Brearley, Mrs. E.A. (Ella) Rowley, Mrs. John M. (Ella) Fix, Mrs. Curtis E. (Eliza) Thatcher, Mrs. James M. (Emma) Howe, Mrs. J.D. (Lillie) Kester, Mrs. Eugene (Mary) O'Neill, Mrs. F.J. (Emma) Edwards and Miss Alice Frazier. Women became eligible to serve on juries in Idaho in 1896, when they were granted the right to vote. However, jury service by women was rare since Idaho trial judges and the Idaho State Bar reserved jury duty for men. In the 1920s, prosecutors preferred having female jurors on cases involving prohibition violations. However, when an all-female jury convicted

a man for unlawful possession of alcohol, he appealed his case on the grounds that women were ineligible to serve. The Idaho Supreme Court upheld his appeal, and the next legislative session defeated a bill that would have guaranteed the right of women to serve as jurors. It was not legal for women to serve on juries in Idaho until 1943.

Mueller, Gene. *Natives, Migrants and Immigrants: Lewiston's Cultural Heritage and Early Society*. Lewiston: Association of the Humanities in Idaho, National Endowment for the Arts, 1980, 21.

State v. Kelly, 39 Idaho 668 (1924).

1897: FIRST QUEEN OF THE IDAHO INTERMOUNTAIN FAIR

Although called the Western Idaho Fair, the annual event is the de facto state fair of Idaho. The fair began as the Idaho Intermountain Fair in 1897 as an agricultural and livestock exhibition. The fair arose out of a need to connect Boise and other larger cities that were three hundred miles apart. With Boise's strong agricultural roots, the first fair featured three major departments: livestock (sheep, cattle, horses and hogs), products of the soil and a domestic manufacturing/ home department. These bigger categories were subdivided

in later years into smaller departments that can still be found today. Lewiston's Bessie Vollmer, eldest daughter of John and Sarah Vollmer, was named the first queen based on the 3,818 votes cast by supporters across the state. Idaho governor Frank Steunenberg, along with other state and federal officials, took part in her inauguration. On September 4, 1901, she married Arthur E. Clarke, then an executive of the New York Life Insurance Company. Clarke would later take over all of Vollmer's banking interests.

Salt Lake Herald, October 6, 1897, 5; August 1, 1898, 6.

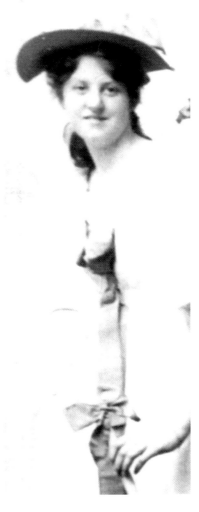

Bessie Vollmer, 1893.

1898: IDAHO'S FIRST AFRICAN AMERICAN PHYSICIAN (BASED ON THE BEST EVIDENCE)

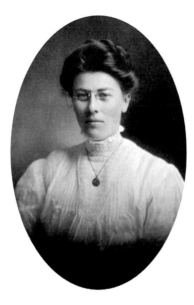

Dr. Angelina G. Hamilton, 1908.
Courtesy of the Bentley Historical Library, University of Michigan.

Dr. Angelina (Nina) Grimké Hamilton had history on her side. Born in 1872, she was the granddaughter of Angelina Grimké Weld, famed abolitionist writer and women's suffrage advocate. In 1838, Weld became the first woman to address a legislative body when she spoke to the Massachusetts state legislature on women's rights and abolition. Hamilton graduated from Chicago's Hahnemann Medical College & Hospital in 1897 with a degree in homeopathy. After some work in the Amish community of Shipshewana, Indiana, she headed west. Her "professional card" began appearing in the *Lewiston Daily Tribune* on July 28, 1898. She remained in practice here until after the June 1900 federal census was filed. Hamilton returned

to Illinois by 1901 and served as an assistant physician at the Cook County, Illinois Insane Asylum. To assist her widowed father, she relocated to Benton Harbor, Michigan, and entered the University of Michigan, earning an MD in 1908. For the next thirty-nine years, Hamilton worked in the Illinois state mental hospital system as a psychiatrist. When the University of Michigan surveyed more than ten thousand alumnae in 1924, Dr. Hamilton responded by writing "mixed" on the line to indicate race. She died in April 1947 in Port Huron, Michigan. The Annex Building at Anna State Hospital, Anna, Illinois, was renamed in her honor. See "1951: Idaho's First African American Registered Nurse" and "1992: Idaho's First African American Judge."

Bentley Historical Library, University of Michigan, Ann Arbor.

1898: IDAHO'S FIRST NEWSPAPER TO RECEIVE TELEGRAPHIC NEWS DISPATCHES

The *Lewiston Tribune* began publication on September 29, 1892, in a very humble fashion, appearing every Thursday as a seven-column quarto (eight pages). Published by brothers Albert and Eugene Alford, the newspaper began biweekly distribution in 1895. In May 1898, the publication became the *Lewiston Daily Tribune*, but by

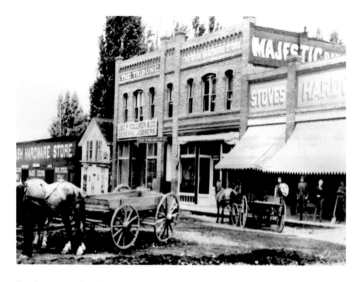

Lewiston Morning Tribune building, D Street, circa 1898.

October the newspaper had moved to a morning edition, renamed itself the *Lewiston Morning Tribune* and upgraded its production to a Mergenthaler linotype, the second in Idaho. In the fall of 1898, the newspaper became Idaho's first to receive Associated Press news feeds via Morse code, reporting dispatches from the Philippines, where Company B (First Idaho Volunteers) was fighting to put down the local insurrection following the treaty ending the Spanish-American War. Morse code was replaced by teletype in the 1920s. See "1995: Idaho's First Newspaper to Go Online."

1899: IDAHO'S FIRST CASUALTY IN A FOREIGN WAR

The dispatch detailing the death of Lewiston's Edward McConville was a major blow to Lewiston. When he was killed in action against the forces of General Antonio Luna at the Battle of La Loma in the Philippines on February 5, 1899, the Idaho regiment vented its anger by advancing at the quick march against a superior enemy force. General King, knowing he could not call them

Edward McConville. *Courtesy of the Idaho Military Historical Society.*

back, finally said, "There go the Idaho savages, and all hell cannot stop them." A Civil and Nez Perce War veteran, McConville was one of Idaho's most esteemed leaders. His funeral in April is said to have been the largest ever held in the city. The service was postponed for two days to allow the state dignitaries to travel from Boise to Lewiston by steamer and rail. McConville lay in state at the courthouse and then at the Masonic Hall on First

Street. An estimated six thousand people took some part in the services, which began at the Masonic Temple. The ceremony was followed by a "most elegant oration" that lasted two hours. The weather was miserable, with "a bitter wind lashed with rain." The funeral procession was drummed up Main Street by cadets and fraternity men from the University of Idaho. Attendees included Governor Frank Steunenberg, the state auditor, all members of the Idaho Supreme Court, two companies of the University Cadets and a large delegation of old friends and comrades.

"Idaho File into History." In *Pass in Review*. Boise: Idaho
 Military History Society, September 2004, 9.

1899: IDAHO'S FIRST MUNICIPAL PARK
(BASED ON THE BEST EVIDENCE)

What is now known as Pioneer Park was the original city cemetery for more than thirty years, having been replaced by late 1889. The area remained unused during several exhumation projects. The location of the park was slated to hold a new Masonic Lodge, church and Catholic hospital, but the plans for these structures failed to materialize. The Fifth Street Park was created by the city council on June 14, 1899. The first use of the new

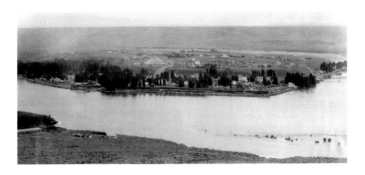

Fifth Street Park, July 1899. The park is seen in the photo where the large circus tent is located.

park came in late June, when the Ringling Bros. and Barnum & Bailey Circus arrived by train and pitched tents across Normal Hill. Archaeological fieldwork from 2001 to 2007 demonstrated that the park contains as many as two hundred graves. The Carnegie and Idaho Supreme Court Libraries were constructed in the park in 1904–05. A band shell and public fountain were added by 1911. The park was renamed Pioneer Park in 1936, during the centennial celebration for the Henry Spalding Mission.

Minutes of the Lewiston City Council, June 14, 1899.

1899: IDAHO'S FIRST
COLLEGE DORMITORIES

Lewiston State Normal School was authorized in 1893 by the state legislature, which failed to provide adequate funding. Lewiston donated the land for the campus. George Knepper, the school's first president, arrived for work on November 1, 1895, and found that construction delays left him without a building in which to teach. He approached Robert Grostein and Abraham Binnard to rent their local theater for classes to begin on January 6, 1896. The new building was finally completed and dedicated with great fanfare on June 3, 1896. Knepper struggled with money issues to keep the school going. Although the enrollment and income from student fees had increased, the school remained desperately short of funds. So Knepper turned to the community. Residents responded with a needed piano and contributions to buy books to start a library.

The school was located on land within the city limits, but housing was limited on Normal Hill, so students were forced to walk to classes from lodgings downtown. Supplemented by an appropriation from the 1897 legislature, Knepper arranged for labor and materials to be donated at-cost to construct badly needed dormitories. The men's dorm, Reid Hall, was supervised by Henry Talkington, a new faculty member, and had nineteen residents, who were called "inmates" in the newspapers of the day. Opening

Lewiston State Normal School campus, circa 1901. Reid Hall is seen on the left and Morris Hall behind the Training School on the right.

on November 25, 1899, with eleven young women and headed by Miss Bloom, the "Ladies' Hall" (Morris) had a kitchen, and that was the extent of the amenities. The buildings were made of rough board and batten, with no inside plumbing. The men dug the cesspools. There was a long outdoor passageway leading to the washbasins and pit toilets. By the fall term of 1904, the dormitories were full, forcing many students to seek lodgings in the new neighborhoods that had grown up near the Normal.

Morris Hall burned down in 1907. Reid was condemned and sold for $650 ($15,000 today), the money going to help construct Lewis Hall, the new women's dorm. Reid was sawn in half and moved to the base of Tenth Street near Miller Grade and converted into two stately homes. Men would not again have on-campus housing of their own

until 1930, when Spalding Hall became available after the college opened Talkington Hall.

Petersen, Keith. *Educating the American West.* Lewiston, ID: Confluence Press, 1993, 37.

1900: IDAHO'S FIRST PROFESSIONAL TOWN LIBRARIAN (BASED ON THE BEST EVIDENCE)

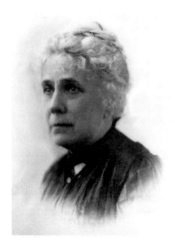

Margaret Guyer. *Courtesy of the Lewiston City Library.*

With the death of Margaret Guyer on March 25, 1933, Lewiston lost a pioneering cultural and literary leader. One of the best-known women in central Idaho, Guyer was Lewiston's librarian for more than thirty years and nurtured the collection from a few books on donated shelves at the old city hall on Third Street to the state-of-the-art holdings at the Carnegie Library, where she worked until her retirement at the age of eighty. Records indicate that she was the first public librarian in the state of

Idaho, hired by the city on May 21, 1900, at $5 ($130 today) a month. Although a few Idaho towns had functioning libraries and librarians before 1900, this is the earliest reference to a librarian being placed on a city payroll. By 1913, her salary had increased to $75 ($1,700 today), which was "less than any city of like size in the United States." A Pennsylvania native born to a prominent and wealthy family, Miss Guyer moved to Lewiston in 1896 after her brother John assumed a role as legal counsel for the Nez Perce tribe and Indian agency. In her 1933 obituary, the *Lewiston Morning Tribune* commented, "An ardent student, she read diligently and became a splendid judge of books and sundry publications. Both young and old looked to her for guidance and found sympathetic understanding and advice." See "1878: Idaho's First Public Library."

Lewiston Morning Tribune, April 29, 1913, 5; March 27, 1933, 8. *Minutes of the Lewiston City Council*, May 7, 1900; May 21, 1900.

1900: FIRST WOMAN TO BE A DELEGATE TO A NATIONAL POLITICAL NOMINATING CONVENTION

Soon after arriving in Lewiston in 1898, Susan Henderson West assumed an active role in Idaho politics and was one of the first two women to be delegates to a national political convention,

Susan Henderson West.

attending the Republican gathering in Philadelphia that nominated William McKinley for a second term in June 1900. She was a delegate again in 1904. Although *Leslie's Magazine* conceded that she was "a vigorous and able speaker" and "a successful campaigner," the editors added that she "never forgot her true sphere of life, that of a wife and mother." West became a lawyer in 1908 and served for many years as clerk of the Idaho Supreme Court. After the passage of the Nineteenth Amendment granting the vote to women in 1920, she observed, "It was said that womanhood would be lowered by the ballot, but there is nothing lowering in our going to the polls. I think that our getting the franchise has had a splendid effect on politics generally."

Freeman, Jo. *A Room at the Top: How Women Entered Party Politics*. Lanham, MD: Rowman & Littlefield Publishers, Inc., 2000, 65.

Gustafson, Melanie Susan. *Women and the Republican Party*. Champaign: University of Illinois Press, 2001, 79.

1901: Idaho's First YWCA
(New Evidence Indicates 1899)

The first student YWCA chapter was organized at Normal University in Illinois in 1872. By 1890, the familiar YWCA blue triangle could be found in cities and on college campuses all over the United States. Until 1906, the civic and student organizations operated separately. Of the

Lewiston
State Normal
YWCA
officers, 1904.

186,000 members, 22 percent were students. Both groups of YWCAs in the United States decided it was time to merge under a single name: the Young Women's Christian Association. The YWCA at Lewiston State Normal School may date from as early as 1899, when the women's dormitory was opened. The 1904 college yearbook reports that Maggie Miller represented the group at the 1902 national convention in Capitola, California. The early YWCA was much more faith based than today. The organization was focused on furthering Christian missionary work among students. The first "city association" YWCA opened in Boise in 1910, with Lewiston following in 1919.

Koos-koos-kee, 1904.

1901: NATION'S FIRST SELF-CONTAINED REFRIGERATED FRUIT SHIPPING (BASED ON THE BEST EVIDENCE)

The shipment of fruit packed in ice from the West began in 1895, when Ignascio Allegritti demonstrated the use of a refrigerated car in Walla Walla. A car was loaded with pears and held for five days, after which it was successfully shipped to the East Coast. According to the June 23, 1901 *Spokesman-Review*, Lewiston's Leslie Albert Porter "inaugurated an innovation in marketing fruit that

L.A. Porter farm, circa 1905.

some shippers think is destined to almost revolutionize fruit shipping in the northwest." Porter designed a self-contained, mechanically refrigerated container that held fifty boxes of cherries and was shipped as a single unit. His marketing experiment resulted in his selling the refrigerated cherries for $8 ($207 today) per box, compared to $3 ($78 today) per box for unrefrigerated cherries. Established in the 1880s, the forty-acre Porter farm had vineyards bearing as many as fifty-four varieties of grapes. At the turn of the twentieth century, a rail spur was run to the area, and Lewiston teens would come to pick fruit. Trains stopped at what was called Porter Station. Located on the site of the old Potlatch Corporation millpond, the Porter home was spacious, boasting twenty-two rooms.

A bunkhouse (Porter's original home) served up to forty men. The Clearwater Timber Company purchased his properties in 1922 for $95,000 ($1.2 million today).

1902: IDAHO'S FIRST FEMALE DOCTOR OF OSTEOPATHIC MEDICINE
(BASED ON THE BEST EVIDENCE)

Dr. Henrietta (Hattie) A. Lorton was a popular Butte, Montana osteopath who became very tired of Butte's long and cold winters. She attended the Columbian School of Osteopathy, Medicine and Surgery in Kirksville, Missouri, where she completed the twenty-month curriculum in February 1899. After serving many of the most prominent Montana families, she came to Lewiston and its milder climate highly recommended by her former patients. Lorton set up her offices in the old Weisgerber Building at the head of Second Street on Main. In her first "professional card" advertisement in the January 18, 1902 issue of the *Lewiston Morning Tribune*, she offered "free consultations." In June 1903, her office was located in the new Idaho Trust Company building, where she maintained three rooms and gave free examinations. By September 1905, Dr. Lorton had resumed her practice in Butte. Osteopaths were not licensed in Idaho until 1907.

Idaho State Board of Medicine

1903: IDAHO'S FIRST IMPLEMENTATION OF THE EIGHT-HOUR WORKDAY (BASED ON THE BEST EVIDENCE)

On March 2, 1903, the eight-hour workday went into effect for Lewiston's local building trades unions (Masons and Bricklayers Local No. 4), with wages set at $0.45 per hour ($11.00 today). The local laborers' union settled for $2.50 per day ($60.00). Two months earlier, the carpenters' union had posted resolutions declaring that on March 2 eight hours would constitute a day's work. All of the contractors in town agreed. Most Americans worked twelve- to fourteen-hour days. Although a popular concept, Idaho did not pass a prevailing wage law until 1911. The first federal law that regulated the hours of workers in private companies was the Adamson Act (1916). By comparison, in 1933 the federal minimum wage was $0.33 ($5.50) per hour. In April 1904, local plasterers, bricklayers and stonemasons tried in vain to organize as a branch of the international union. The action was regarded as "antagonistic to the movement recently instituted here looking to the organization of a trades council by labor unions affiliated with the American Labor Union."

Azari-Rad, Hamid, Peter Philips and Mark J. Prus. *The Economics of Prevailing Wage Laws*. Burlington, VT: Ashgate Publishing Co., 2005, 13.

1903: IDAHO'S FIRST EXCLUSIVE MORTUARY

The Vassar Funeral Home began its operations on January 1, 1898. J.O. Vassar, his son C.J. Vassar and F.B. Willis started originally as partners in a furniture store in the old Grand Hotel building at Third and Main Streets. At the time, this was not an uncommon business combination. In 1903, C.J. Vassar opened the first exclusive mortuary in the state. In 1907, the business moved into the former Robert Grostein home, which had been built in the early 1880s and sat at 608 Main Street. The building was remodeled as a funeral home. In July 1912, the building was cut in half and moved on log

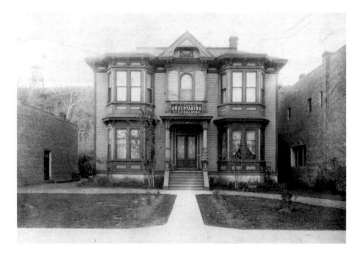

Vassar Funeral Home, circa 1910. *Courtesy of Vassar-Rawls Funeral Home.*

rollers to Ninth and Idaho Streets. In 1933, E.S. Rawls and Vincent Vassar entered the business, which is now located at 920 Twenty-first Avenue. The old home still stands. See "1862: Idaho's First Jewish Permanent Resident."

Lewiston Morning Tribune, May 25, 1927, 7.

1904: IDAHO'S FIRST HEAVIER-THAN-AIR FLIGHT

First officer of the steamer *Spokane*, Stewart Winslow was a tinkerer. In his spare time over a period of four months, he built a glider that was a cross between a bicycle and a kite. His friends teased him, but he knew it would fly. On July 30, 1904, Winslow felt he was ready and invited reporters and photographers to a bluff overlooking the current site of the Lewiston Country Club. Because the contraption depended on momentum to create lift, Winslow intended to pedal down the slope. On the first trial run, the glider lifted from the ground several times. The front wheel then broke. It seems that stubble in the field had punctured the tire. Winslow planned to lay down a wood runaway on the next try, but the second trial never happened.

That would seem to be the end of the story, but in 1931, "Winslow's Folly" was back in the news. A French inventor had filed a patent infringement suit against the

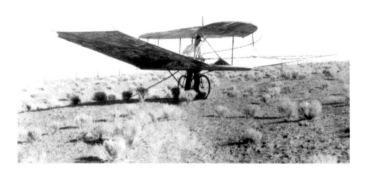

Stewart Winslow.

U.S. government over the joystick design it was using in its aircraft. That design had been created by Stewart Winslow. Living in Portland by that time, he re-created the device for the government's attorneys.

Lewiston Morning Tribune, July 30, 1904.

1905: IDAHO'S FIRST CARNEGIE LIBRARY

Members of the Tscemincum Club were surprised on April 14 when hundreds attended the opening of the new Carnegie Library in the Fifth Street Park, keeping the

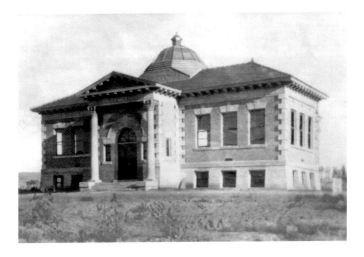

Carnegie Library, 1905.

library open until 10:00 p.m. Working from plans drawn by I.J. Galbraith (Spokane), the company of Frazer & Booth erected the building during 1904 and early 1905. In 1903, the city had committed $1,000 ($24,000 today) to ensure construction. The Andrew Carnegie Library Foundation, responding to an appeal from Mrs. C.W. Shaff, donated $10,000 ($240,000 today). The Tscemincum Club had established a city library with a few books and shelves in city hall in May 1900. The new library was capable of holding ten thousand volumes. It closed its doors on September 30, 1999. While Boise received its Carnegie grant before Lewiston, its library did not open until two months after the Lewiston facility. See "1878: Idaho's First Public Library."

1906: IDAHO'S FIRST ENDORSEMENT OF A CANDIDATE FROM THE OPPOSING PARTY

The Nez Perce County Democratic Party convention met in Lewiston on August 21 to nominate legislative and county tickets. The candidacy of Judge Edgar C. Steele of Moscow for reelection as judge in the Second Judicial District was endorsed. What made the action unusual was that Steele was a Republican. It was the first time this happened in Idaho. The state Democratic Party was pressing for a nonpolitical judiciary. Counties vied to have district court judges as residents. The decision at the Lewiston meeting was probably not what they expected. First elected in 1898, Steele would serve on the bench until his death from pneumonia in July 1929. Idaho Republicans have a closed primary, while Democrats have a semi-closed one.

1906: FIRST HIGH SCHOOL BAND IN THE PACIFIC NORTHWEST

Created by William Lotzenheiser, the band accompanied the track team to interscholastic meets in Pullman and Walla Walla. The band was an experiment, and few of the students had any musical experience. J.B. Pollard, a cornetist, became director in 1908 after Lotzenheiser's

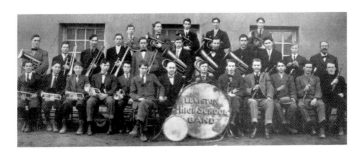

Lewiston High School band, 1910. *Courtesy of the Lewiston High School Archives.*

death. Music was not a regular school subject until 1910. In that year, the band furnished the music for the Lewiston-Clarkston Interstate Fair, a task usually given to the Walla Walla Military Band or the Lewiston City Band. The high school had its first orchestra by 1910, also under Pollard's direction. See "1910: Idaho's First Powered Flight."

Purple and Gold. Spokane, WA: McDermid Engraving Company, 1911, 64.

1907: FIRST FEMALE PHYSICIAN TO SERVE ON THE IDAHO BOARD OF HEALTH

Dr. Susan E. Bruce began her medical career in Chicago in 1880 after graduation from Hahnemann. In 1905, she visited Lewiston and liked the area so much that she moved her

Dr. Susan E. Bruce, circa 1928.

homeopathic practice here in 1906. In 1907, Governor Frank Gooding appointed Dr. Bruce as one of the first three physicians to serve on the Idaho Board of Health (now the Idaho Board of Health & Welfare). She was the first vice-president of the newly formed Idaho Homeopathic Society in 1909. Bruce was elected Lewiston's health officer in 1911, eventually serving seventeen years and becoming by many estimates the most important physician to serve the city. Dr. Bruce was instrumental in controlling the local smallpox outbreaks of 1913 and 1927. During the Spanish influenza outbreak in 1918–20, she forbade public gatherings, closed schools, banned lodge meetings and canceled church services to help curtail contagion. Fifty-three Lewiston residents died in the pandemic. Many credit the relatively low death toll to Dr. Bruce's foresight. She died in December 1930, shortly after her retirement at the age of eighty-two.

Lewiston Morning Tribune, December 25, 1930, 8.
The Clinique. Vol. 28. Chicago: Halsey Brothers Company, 1903, 581.

1907: First Woman to Be a Member of the American Society of International Law

The American Society of International Law (ASIL) is a nonprofit, nonpartisan, educational membership organization founded in 1906 and chartered by Congress in 1950. When the first annual meeting was held in April 1907, one woman—Mary Elizabeth Urch, dean of women at Lewiston State Normal School—was included in the list of charter members. Born in 1872, she emigrated from England in 1876, graduated from Albion College in Michigan in 1893 and taught English in Grand Rapids and at Central Michigan Normal (now Central Michigan University) before coming to Lewiston. At Lewiston State Normal, Urch taught English and was advisor to a literary society that met every two weeks "for the purpose of debating some pertinent question."

There was one problem: Only "men of affairs" were eligible for membership in the ASIL. Records from the treasurer's office show that her dues were accepted, along with those of seven men. Urch stayed on the

rolls through 1908. Women did not become formally eligible for membership until 1920. It is still a mystery at ASIL how she infiltrated the group. It should be noted that women more prominent than Urch were denied membership, including Jane Addams, of Hull House fame and a Nobel Peace Laureate. After earning a master's at Columbia University in 1910, by 1918 Urch had moved back to Michigan, where she taught for several years. She died in 1946.

Kirgis, Frederic L. *The American Society of International Law's First Century: 1906–2006.* Boston: Martinus Nijhoff Publishers, 2006, 12.

Evans, Alona E., and Carol Per Lee Plumb. *Notes and Comments: Women and the American Society of International Law.* 86 AJIL 290. 1974.

1907: IDAHO'S FIRST CITY WITH A COMMISSION FORM OF LOCAL GOVERNMENT

The city commission form of municipal government was once common in the United States and was first developed in Galveston, Texas, after the great hurricane of 1900. Voters elected a small commission, usually five to seven members, on a plurality, at-large basis. Lewiston originally had seven commissioners until the

state legislature amended the system to elect only five members and to allow cities with populations of more than three thousand to adopt the system by popular vote. The state plan had no provision for a referendum. The commissioners made up the civil government. One member was elected by the group to be mayor. Each commissioner was a head of a city department. Therefore, the system had some limitations, especially the weak executive authority held by the mayor, as each commissioner had both legislative and administrative powers. After World War I, many cities switched to the council-manager form of government. Portland is the only large city in the United States to still have a commissioner form of government. Lewiston changed to the council-manager system in 1965. William Steffey was named the first city manager of Lewiston. Nearly eighty people applied for the position. The city changed its municipal government to the mayor-council format in 1964, but the change required action of the state legislature to amend the city charter and make it official.

Flower, Benjamin Orange. *The Arena.* July 1909, 110.
Taylor, C.F. *Equity* 12, no. 1 (1910): 15.

1907: IDAHO'S FIRST ORGANIZED YOUTH BASEBALL LEAGUE
(BASED ON THE BEST EVIDENCE)

Lewiston has long been known as a baseball town. Once found in the middle of the Clearwater River, Holbrook Island was a favorite location of pickup games. Baseball was played in Idaho as early as 1868, but competition was limited to military and town teams for decades. Photographs of Lewiston teams made up of junior high and high school players date from before 1895. Lewiston teenager Ransom Coburn played for the Chicago White

Lewiston Stars, circa 1889.

Sox from 1884 to 1887. By 1906, Lewiston High School was playing the University of Idaho. By 1913, local towns—including Lewiston, Grangeville, Reubens, Cottonwood—competed in the North Idaho League. A special train carried spectators to the games. Lewiston first fielded a semipro team in 1921 for the Northern Utah League. The high school has won the state championships eleven times. The American Legion team has won the state title thirty-eight times, beginning in 1939. Lewis-Clark State College has been the NAIA national baseball champion seventeen times.

Lewiston Morning Tribune, March 15, 1992.
Spokesman-Review, February 22, 1909, 13.

1910: IDAHO'S FIRST POWERED FLIGHT
(BASED ON THE BEST EVIDENCE)

On October 13, 1910, aviator James "Jimmy" J. Ward made the first powered flight in the state of Idaho. Ward took off in a 1909 Model D Curtiss Pusher from the Interstate Fairgrounds in Clarkston after solving several mechanical problems and flew over the confluence of the Snake and Clearwater Rivers, evidently passing for a few minutes into Idaho air space. Ward barnstormed across the United States. On September 13, 1911, Ward left Governor's Island, New

James J. Ward in flight.

York, as part of a transcontinental race. He would withdraw from the contest after 310 miles because of mechanical failure. His barnstorming lifestyle led to legal problems. On June 1, 1912, he was arrested for bigamy.

Flying Idaho (Idaho Public Television)

1911: FIRST PACIFIC NORTHWEST LIVESTOCK SHOW

Ten leading cattle dealers in Idaho and Montana joined forces to create the Northwest Livestock Association. The

December 11, 1911 issue of the *Lewiston Morning Tribune* quoted association president Paul Clagstone as saying, "The people will have opportunity here this week to see the best livestock show ever assembled in the northwest. I make this statement with full information as to the best exhibitions of that character ever made at any of the large northwest fairs or ever assembled for any other event of this character in this part of the United States." Events began with a reception and performances at the Temple Theater. The exhibition was a yearly feature into the 1920s, only interrupted in 1918 as a result of the Spanish influenza. The old Lewiston Hill Highway opened with a ceremony on November 26, 1916—the Sunday before the opening day of the annual show. The first show brought a large delegation from Spokane to analyze how Lewiston was organizing the project.

1914: IDAHO'S FIRST SCHOOL DISTRICT TO ADOPT THE 6-3-3 PLAN AND OPEN A JUNIOR HIGH SCHOOL

The years just prior to the outbreak of World War I witnessed a major shift in how American schools were organized. As high school curriculums developed across the country in towns where the eighth grade was once the final year of education, administrators saw a need

Lewiston Junior-Senior High School, 1916. The junior high school occupied the wing on the left in the photograph. *Courtesy of the Lewiston High School Archives.*

for a systematic track of instruction. The result was the junior high school, with the first ones opening in Berkeley, California, and Columbus, Ohio, in 1909. Lewiston joined the movement in the West under the leadership of Frank W. Simmonds, superintendent from 1913 to 1920. Simmonds proposed the 6-3-3 plan in late 1913 and in September 1914 moved the junior high school and high school students into separate wings of the newly completed high school, the center portion of which had been erected in 1910 as a gymnasium and manual arts building. Simmonds described the program as a "six-year high school." The school had its own principal and was described as being "well-matured...with a splendid curriculum" in 1919. The building served as a junior high school until 1959 and was razed ten years later.

Course of Study and Rules and Regulations of the Lewiston City Schools. 1914, 88–91.

Johnston, Charles Hughes. *Education Administration & Supervision*. Baltimore, MD: Warwick and York, Inc., 1917, 107–12.

Llewellyn, E.J. "Junior High School in Lewiston, Idaho." *Elementary School Journal* 16 (May 1916): 454–56.

1914: First Idaho Woman to Fly
(based on the best evidence)

On September 30, 1914, Velma Peterson went aloft in a Curtiss biplane for eight minutes with pilot Terah E. Maroney at the old fairgrounds once located at the current site of Clearwater Paper Company. Flying at an altitude of seven hundred feet, they reached a speed of seventy miles per hour, powered by a seventy-five-horsepower engine. After her eleven-mile flight, Velma told reporters:

> *You are way up in the air where nobody else has been and where the entire country is unfolded before you, and you are shooting through space as in a dream. I cannot tell you what the sensations are, but they are thrilling and fascinating and I will always remember. I thank Maroney for the splendid ride he gave me.*

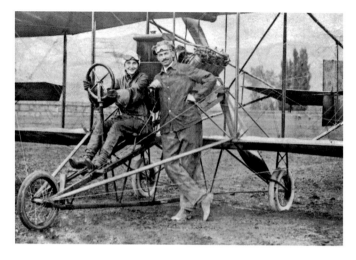

Velma Peterson and Terah E. Maroney.

Maroney gave William E. Boeing his first airplane ride the next year. He was killed in 1929 while hand-starting his airplane. It should be noted that Peterson was not the first woman to fly in Idaho. That honor goes to Alys McKey Bryant, a pioneer female pilot who made exhibition flights in Idaho in 1913.

1918: IDAHO'S FIRST STATE HIGH SCHOOL TRACK AND FIELD CHAMPIONS

Lewiston High School was competing in large interscholastic track meets soon after opening its new campus in 1904. In 1906, led by sprinter Lloyd Fenn, Lewiston defeated teams from all over eastern Washington and northern Idaho, winning the Inland Empire Championships. In 1918, Idaho instituted a state track meet that included athletes from all its schools. Lewiston would win for three consecutive years (1918–20). The school's last state track championship was in 1956.

Idaho High School Athletics Association. Publication DF2C2d01.

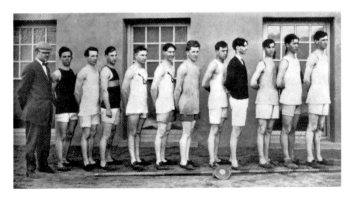

Members of the Lewiston High School track team, 1911. *Courtesy of the Lewiston High School Archives.*

1919: Idaho's First World War I Veterans' Group
(Based on the Best Evidence)

Fifteen returning Lewiston soldiers and sailors formed the group World War Veterans on February 1. Within the month they had renamed themselves Great War Veterans, taking the name from the Canadian organization created in Winnipeg in 1917. The group had 150 members by March and began publishing the *Great War Veterans Bulletin* in April. The organization was clearly a response to recent events affecting Lewiston. Company F of the Idaho National Guard was mobilized on March 26, 1917, in anticipation of entry into the First World War. The company had been home for only a month from service along the U.S.-Mexican border, where it had been on active duty for seven months in the campaign against Pancho Villa. Charles B. Maynard, 84th Company, 6th Regiment, U.S. Marines, died on June 7, 1918, from wounds received in action and was later awarded the Croix de Guerre by French marshal Philippe Pétain. Maynard attended Lewiston High School before enrolling at Lewiston State Normal School and Washington State College, where he excelled in athletics. He was commissioned second lieutenant, Idaho National Guard, in 1915 and served in Mexico with Company F. First Lieutenant Raymond C. Hill, a faculty member at Lewiston High School from 1906 to 1908, was killed in aerial combat

at La Chaussee, France, on September 14, 1918. He was awarded the Croix de Guerre in the Rheims sector in June 1918. In August, he was again cited for bravery, this time at Frapelle, France. On October 18, 1918, Sanford Brewer Dole, Company E, 128th Infantry, was killed in action at the Argonne, France. Dole graduated from Lewiston High School in 1914 and served in the Mexican Campaign. He was commissioned second lieutenant on October 1. Sanford was the younger brother of well-known Lewiston resident Ira Dole.

The Lewiston group affiliated with the American Legion after that organization began chartering posts in May 1919, with Lewiston becoming the thirteenth in the state.

Lewiston Morning Tribune, March 12, 1938, 5.

1919: FIRST SITE OF THE NATIONAL LIVESTOCK ROUNDUP FUTURITY SHOWS

The Duroc is an older breed of American domestic pig that forms the basis for many mixed-breed commercial hogs. Duroc pigs are red, large framed, medium length and muscular, with partially drooping ears, and tend to be one of the most aggressive of all the swine breeds. As early as 1917, the Poland China and National Duroc-Jersey Record Association (DJRA) was supporting the competition in

Lewiston. In 1919, the DJRA made the Lewiston fair the first in the Northwest to host the National Northwest Livestock Roundup Futurity Shows. In 1920, the National Duroc Club held its very first national competition in Lewiston. The work of the club was assisted in North Idaho with assistance from Armour & Company, which gave breed sows to members.

National Duroc-Jersey Record Association. Vol. 55. 1918, xii.

1920: FIRST WOMAN TO BE THE SECRETARY OF A STATE POLITICAL CONVENTION

Olive M. Petrashek was named secretary for the Idaho State Democratic Convention, held in Lewiston on June 15, 1920, being the first woman in the United States to hold that office at that level. Petrashek studied at Lewiston State Normal School and taught in Nebraska before becoming the county superintendent of schools for Washington County, Idaho, for many years. In 1920, she was nominated by her party to run for state superintendent of public instruction, but she declined the nomination. In 1931, she married Oscar Hailey, then Idaho's lieutenant governor. Petrashek died in 1960.

Hawley, James. *History of Idaho: Gem of the Mountains*. Vol. 4. Chicago: S.J. Clarke Publishing, 1920, 548.

1920: FIRST STATE OFFICE OF EDUCATIONAL TESTING AND MEASUREMENT IN THE WEST

Idaho began developing state achievement/content standards in 1994. Long before the Idaho Standards Achievement Tests were instituted statewide, the State

Dr. Charles L. Harlan. *Courtesy of Lewis-Clark State College.*

Department of Education established a center at Lewiston State Normal School to coordinate all educational tests, measurements and standards across the state. The first director was Dr. Charles L. Harlan, who had joined the faculty in 1919 and was serving as chairman of the Education Department. The bureau staff visited school districts and instructed teachers on how to administer the statewide exams in reading, arithmetic, language and grammar and in general intelligence. The results were tabulated and made available to school district superintendents and teachers in twenty-three school systems that first school year, in which more than thirty-five thousand tests were given. Harlan had extensive experience with testing at the Universities of Indiana, Illinois, Pennsylvania and Minnesota and had worked for the army giving proficiency tests to soldiers during World War I. Dr. Harlan retired with the closing of the college in 1951 and moved to California, dying there in 1964.

Journal of Educational Research. Vol.1. Champaign: University of Illinois Press, 1920, 423.

1922: IDAHO'S FIRST INDEPENDENT MOTION PICTURE

Miss Lewiston, Idaho's first "indie," was filmed over a period of ten days in June 1922. Some three hundred people were

involved in making the film, many from Lewiston and Clarkston, Washington. According to the *Spokesman-Review*, the star (Emma Moore) was selected by "voters," who were purchasers of tickets at a local theater, which proved to be the only place the film was shown. Allen H. Hilton directed the film and owned the theater. Hilton was an amateur filmmaker who had been in the cast of the 1919 version of *Westward Ho!* Lewiston's city officials played themselves in the film. No copies of the twenty-minute motion picture have survived. The cast included John Gipson Stalker and A.A. Seaborg Sr. A former yell king at the University of Idaho and scion of one of Caldwell's leading families, Stalker was city editor of the *Lewiston Morning Tribune*. Seaborg was the secretary of the Lewiston-Clarkston Fair and a trustee of the newly opened Lewis-Clark Hotel.

Idaho Statesman, May 31, 2005.

Wiernega, Jeremiah Robert. "Idaho Struggles to Get a Foothold in the Film Industry." *Boise Weekly*. November 26, 2008.

1922: Idaho's First Radio Broadcasting License

On July 6, 1922, KFBA was granted the first radio broadcasting license in Idaho. The firm of Ramey & Bryant

Radio Co. held the license. The company broadcast from 307 Main Street, in what is now Morgan's Alley. As with many other early stations, it did not survive for long, going off the air in December of that year. KFAN (Moscow, Idaho) also received its license the same day.

Lynch, Arthur H. *Radio Broadcast*, October 1922, 538.
Radio News, November 1922, 1017.

1924: IDAHO'S FIRST PUBLIC MAUSOLEUM
(BASED ON THE BEST EVIDENCE)

Construction of the Mountain Gem Abbey Mausoleum in Normal Hill Cemetery began in 1924, under the supervision of the Interstate Mausoleum Company, a Detroit-based company with an office in Walla Walla. The building was dedicated on May 30, 1925. In his address, local Methodist minister Mark Pike told the crowd, in part: "Massive and immovable structure of pyramidal permanence and millennial strength, this stately modern mausoleum insures undisturbed and dignified security, in contrast with the ever undesirable and transitory grave or the gruesome incinerator with its supplemental mortar and pestle for the bones of the beloved."

People did not flock to use the building. The first committal did not take place until January 8, 1926. Built

Mountain Gem Abbey Mausoleum during construction, 1924. *Courtesy of Normal Hill Cemetery.*

as a private venture, the building was later deeded to the city. The company and the city were at odds in the late 1930s over the care of the grounds around the mausoleum. City crews had been caring for the tasks, but the company had failed to pay for the services. Eventually, the city took ownership. In October 1961, the city council voted to void the sale of land to the late Ben G. Stone for construction of the structure nearly forty years before. None of his heirs had any interest in the building. The city had a contract with Stone for payment of sixty-five dollars a year rent on the cemetery space occupied by the mausoleum. No payment had been made since about 1940.

Lewiston Morning Tribune, October 24, 1961, 10.

1930: WORLD'S FIRST PRODUCTION OF COMPRESSED WOOD FIBER FUEL

Invented by Potlatch engineer Robert T. Bowling, Pres-to-logs were an artificial fuel for wood-burning stoves developed and produced at the Clearwater Timber plant (later Potlatch Forest, Inc.) as a means of recycling the sawdust from the Lewiston sawmill. The logs were formed from clean, dry sawdust, wood shavings and green waste by machines under great pressure without any binders or glues. Large-scale production began in April 1936. Potlatch announced it would stop production on May 1, 1976, because there were better uses for sawdust and mill shavings. Ray Plourde, the company's specialties manager,

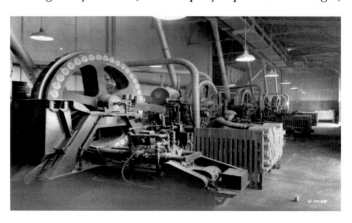

Pres-to-log machinery. *Courtesy of Special Collections and Archives, University of Idaho Library.*

explained, "The material can be put to better use in the manufacture of particle board, as fuel for our boilers and as shavings for the pulp mill." Pres-to-logs were the first diversification for the company, at the time only a lumber mill. At one time, Potlatch produced 1,500 tons of the logs each month. In 1940, Bowling was awarded the Modern Pioneer Scroll of Achievement from the National Association of Manufacturers.

Family Tree Collection. University of Idaho Special Collections.
Spokesman-Review, April 24, 1976, 2.

1931: PACIFIC NORTHWEST'S FIRST GRAIN ELEVATORS BUILT BY THE FARMERS NATIONAL GRAIN CORPORATION

The Farmers National Grain Corporation (FNGC) was formed in October 1929, a new centralized organization to coordinate the existing cooperatively owned grain elevators, terminals and wheat pools, as well as farmer-directed sales agencies. The timing could not have been more ominous, as the Great Depression began to decimate America's farms. The injection of FNGC money into the local economy helped stabilize the flow of grain from large areas of the country. In June 1931, Lewiston Grain Growers (LGG), which was

formed in March 1930, completed construction of its new 130,000-bushel elevators at the Lewiston headquarters on Snake River Avenue. By 1931, LGG (now Primeland Cooperatives) had grown to more than two hundred members with an annual business of 1.5 million bushels.

Lewiston Morning Tribune, Golden Anniversary Edition, 1942, sections 3, 4.

1933: NORTH IDAHO'S FIRST WOMAN TO BE A LICENSED PILOT

On Tuesday, February 21, 1933, Betty Adamson became the first woman in central Idaho to solo in an airplane. Flying a monoplane, she soared over Lewiston from the old airport on Fourth Street in the Lewiston Orchards and made "a graceful three-point landing." Adamson completed her pilot's license after just seven and a half hours of dual flight training with Roy Dickson, manager of the airport. In March, Dickson addressed the local Kiwanis Club to advocate for improvements to the airport, not for passenger service, but for commercial flying to the mining communities in the central Idaho region. See "1914: First Idaho Woman to Fly" and "1944: Idaho's First Commercial Airline."

Sunday Oregonian (Portland), February 26, 1933.

Betty Adamson. *Courtesy of Dave Forsman.*

1935: IDAHO'S FIRST BONDED WINERY AFTER THE REPEAL OF PROHIBITION

Garden of Eaves wine bottle label.

Nez Perce County went dry in 1913, and the state followed in 1915. After the repeal of the Eighteenth Amendment in 1933, the state's industry was slow to recover. Gregory Eaves, a Lewiston orchardist, horticulturist and later Lewiston's parks superintendent who would plant many of the exotic species at his home and throughout Lewiston, established a vineyard on Eighth Street, near the old stone pillars leading to the agricultural development on the tableland above the city, now called the Orchards, and began producing wine from Idaho's first bonded winery. Fifths were sold through the Idaho Liquor Store under the label Garden of Eaves. A grape press from the winery can be seen at the Nez Perce County Historical Museum. See "1862:

Idaho's First Brewery" and "1864: First Grape Orchards in the Inland Northwest."

Lewiston Morning Tribune, August 8, 1994, 1A.

1938: FIRST IDENTIFICATION OF YELLOW STARTHISTLE IN IDAHO

First identified outside Lewiston by a University of Idaho professor, yellow starthistle (*Centaurea solstitialis*) originated in the Mediterranean area and Asia. At the time of the discovery of just two plants, no one recognized the dangers that lay ahead. Yellow starthistle spreads exclusively by seed, which may lie dormant for as long as ten years. Today, more than one million acres in Idaho are affected. The plant causes "chewing disease" and death in horses. Yellow starthistle will flourish wherever downy brome (cheat grass) grows. The introduction of the species into North America probably occurred in California sometime after the start of the 1849 gold rush, a contaminant carried by imported Chilean alfalfa. Many Lewiston residents joke that it is the official city flower.

Westbrooks, Randy G. *Invasive Plants, Changing the Landscape of America: Fact Book*. Washington, D.C.: Federal Interagency Committee for the Management of Noxious and Exotic Weeds, 1998.

1944: IDAHO'S FIRST
COMMERCIAL PASSENGER AIRLINE

Bert Zimmerly was one of Idaho's pioneer aviators, learning to fly in 1930 and logging more than ten thousand hours in the air over his career. In 1938, he formed Zimmerly Air Transport and gained a reputation for mercy flights to stranded people in the Idaho backcountry. He created Zimmerly Airlines (later Empire Airlines) and started trial flights to Boise in 1944, expanding the next year to Twin Falls, Pocatello and Idaho Falls. He purchased several

Bert Zimmerly.

Boeing 247-D ten-passenger aircraft in 1945, when he was certified to carry passengers regionally. In 1948, he switched to DC-3s, which carried 24 passengers. He trained 3,000 pilots as part of his work for the government. In 1946, the airline carried 2,822 passengers. In 1947, the number was 11,518, and by 1950, more that 44,000 passengers boarded the airline's planes. Zimmerly died on February 17, 1949, when his plane crashed near Pullman, Washington, as he was flying to Spokane from Lewiston. He was inducted into the Idaho Aviation Hall of Fame, and the main access road to the Lewiston–Nez Perce County Regional Airport is known as Zimmerly Way. In July 1951, a commemorative plaque was placed atop the Lewiston Hill.

Idaho Transportation Department
Walla Walla Union Bulletin, May 31, 1952, 32.

1945: IDAHO'S FIRST CHARTERED BOYS CLUB

On June 12, 1945, Sheriff W.W. (Bill) Hayes, Deputy Sheriff Bud Huddleston and local businessman Basil Wiggins organized the first group of eighty-five boys in the old Temple Theater. An estimated five hundred boys, ages four and older, paraded through Lewiston on February 14, 1948, asking for public support to build a clubhouse.

Members of the Boys Club, 1946.

Lewiston's police department fully endorsed and assisted with the event. All of the boys carried placards with messages calling for contributions to meet a projected need for $25,000 ($220,000 today) to build a recreational and meeting building. On March 30, 1952, the old Boys Club was dedicated next to Fenton Park (old Vollmer Park). The building cost $16,500 ($135,000 today), which was raised in a fund drive. In April 1961, Decca recording star Brenda Lee performed at the recently opened Nez Perce County Fair Pavilion in a concert sponsored by the Lewiston Boys Club. Proceeds from the two shows went toward refurbishing the old Lewiston Orchards Grange Hall as a clubhouse. The hall was then located on Linden Avenue between Eighth and Ninth Streets. In 1983,

the Boys Club merged with the Girls Center, Inc., and the name Valley Boys & Girls Club was adopted. On December 18, 1993, the Valley Boys & Girls Club opened its Orchards center on Burrell Avenue. Lee was elected to the Rock and Roll Hall of Fame in 2002.

Lewiston Morning Tribune, June 4, 1995, Special 50th Anniversary Insert, 4.

1945: First American Arrested for Collaboration with the Japanese Government during World War II

Before World War II, Mark L. Streeter operated a small fruit farm in Lewiston, later going to work for Morrison-Knudsen Co. and shipping off to Wake Island. He was captured on December 23, 1941, and transferred to Bunka Camp in Japan. In January 1943, the *Spokesman-Review* published a letter that Street had written to Idaho congressman Compton White in 1942, asking White to help stop "this foolish war." At the end of the letter, he sent his greetings to his friends in Lewiston. Streeter worked for the Japanese propaganda office and Radio Tokyo, writing and delivering many broadcasts, including a particularly offensive "Ode to Roosevelt," which was published in Japanese newspapers. His arrest was ordered by General

Mark L. Streeter, circa 1920. *Courtesy of Brenda Pett.*

Douglas MacArthur in early September 1945 on the same warrant with General Hideki Tojo and Admiral Shigetaro Shimada. Streeter told investigators that he was attempting to gain the confidence of his captors and "work from the inside" to speed the end of the war. The case against him was eventually dropped after he turned "state's evidence" against Japanese officials, although the National Archives

still maintains twelve thousand pages of documents relating to his case, with six thousand pages in FBI files.

Streeter returned to Idaho and spoke to the Lewiston Orchards Farmers' Union in August 1951. He was at the time president and director of Energists, Inc., an organization that advocated the elimination of all taxes and had been created, according to Streeter, by him and twenty POWs in 1942. All wages would be stabilized. Unskilled labor would receive the same wage everywhere in the United States, as would semi-skilled, skilled, supervisory and professional labor. Streeter told the *Lewiston Morning Tribune* that he had been a POW from December 1941 until June 20, 1946. What he failed to mention was that the final nine months were as a suspected war collaborator and traitor. Streeter died in Rigby, Idaho, in 1985.

Chicago Tribune, September 13, 1945.
Lewiston Morning Tribune, September 14, 1945, 14.
Toronto Daily Star, September 12, 1945, 1.

1947: IDAHO'S FIRST OUTDOOR DRIVE-IN MOVIE THEATER (BASED ON THE BEST EVIDENCE)

The first of Lewiston's "open-air theaters," later known as an auto-vue or drive-in, opened on May 10, 1947, with a

Auto-Vue construction site, 1947.

"good crowd" despite a light rain. Located at 2714 North & South Highway in north Lewiston (where the Idaho State Police offices are now found), the new theater was operated by Jess Daugherty and his son Lou and was first known as the Natur-Vue. Working from a design by S.L. Brown of Salt Lake City, crews began construction in March 1946. The screen was twenty by thirty feet, and sound was projected by two loudspeakers. At first approximately four hundred cars could be accommodated, but plans were underway to expand to hold one thousand cars. The projection booth was a concrete structure that housed two 35mm machines. The theater cost $25,000 ($250,000 today) to construct. In August, the theater was advertising "a speaker for each car."

On May 22, 1947, a competing drive-in named the Auto-Vue opened nearby. After the 1950 season, the Natur-Vue's advertisement disappeared from the *Lewiston Tribune*, and it is referred to as being closed in subsequent accounts. In 1947, there were only 155 drive-in theaters in the United States. By 1955, there were 4,000. *Billboard Magazine* (July 15, 1950) reported that Hirzel's, a local music store, was lending records to the theater in return for screen credits. The Auto-Vue closed after the 1953 season, when the State of Idaho widened U.S. 95. The first outdoor theater in the Orchards opened at 605 Bryden Avenue in June 1950 as an experiment. In September, the projection booth burned during the showing of a film. A new theater opened in May 1952 on Thain Road. By January 1954, it featured an indoor viewing room and was operating year-round. The last of Lewiston's outdoor theaters, it closed after the 1989 season and was demolished in 1993.

1947: FIRST CITY WEST OF THE ROCKY MOUNTAINS TO FLUORIDATE ITS DRINKING WATER

Studies showing a link between fluoride and teeth began appearing in the early nineteenth century. By 1850, research had established that fluoride occurs with varying concentrations in teeth, bone and drinking water. By 1900,

scientists speculated that fluoride would protect against tooth decay and proposed that the diet should be supplemented with fluoride. On June 10, 1947, Lewiston began adding it to its drinking water, a practice that continues to this day. Conspiracy theories about the use of fluoride were common: a government plot to hide nuclear secrets, industrial "dumping" or a way to cover up the lack of dental care for the poor, to name but a few. A 1950 dental study in Lewiston clearly demonstrated that the frequency of dental cavities among the city's children had dropped dramatically. Lewiston Orchards briefly followed suit but discontinued the practice when the water from the Waha watershed was found to have natural levels of fluoride. Today, 60 percent of American homes have fluoridated water.

Spokane Daily Chronicle, February 11, 1958, 5.

1948: FIRST NATIONAL APPALOOSA HORSE SHOW

The Appaloosa Horse Club holds three nationally recognized horse shows every year: the National Appaloosa Show, the Youth World Championship Appaloosa Show and the World Championship Appaloosa Show. After debuting in Lewiston, the National Appaloosa Show was held at various venues across the country until it had a fifteen-year stay in Oklahoma

City, Oklahoma, beginning in 1993. The show is the nation's oldest single-breed championship event.

Lewiston Morning Tribune, June 19, 1949, 16.

1950: The Nation's First Production of Bleached Paperboard from Sawmill Wood Waste

Construction of the Potlatch Forest, Inc. pulp and paper mill in Lewiston began on December 16, 1950. Potlatch had been focusing its attention on a new product: paperboard, a thick paper with a variety of uses, such as milk cartons and other containers. To manufacture the paper, the company built the new bleached kraft plant, the first facility in the United States to produce bleached paperboard from sawmill waste wood chips. Originally invented in 1879, the kraft process (from German for "strength") was adapted at the Lewiston mill to treat wood chips with a mixture of sodium hydroxide and sodium sulfide, known as white liquor, which breaks the bonds that link lignin to the cellulose. In December 2008, Potlatch divested itself of its Lewiston holdings and created Clearwater Paper Corporation as a spinoff.

Idaho Department of Labor
Potlatch Corporation

1951: IDAHO'S FIRST
AFRICAN AMERICAN REGISTERED NURSE

William Teal was a native of Council Bluffs, Iowa, where his father was a railroad electrician and his mother was a concert singer before the demands of a family forced her to leave the stage. William served in World War II as a medic. In 1948, he began training at the St. Joseph's Hospital nursing school. At the time, his plans included specialized preparation in anesthesiology. The National Association for Colored Nurses listed him as one of only three male African American nursing students in the United States. As Teal neared his graduation from the school, officials contacted the licensing board in Boise to ensure that he

William Teal. *Courtesy of the* Lewiston Morning Tribune.

would be able to take his examinations without hindrance. An African American nursing student in Idaho was a distinct oddity. The *Lewiston Morning Tribune* (November 6, 1949) carried a letter to the editor from a recent hospital patient concerning Teal's care:

> *I remember very distinctly the colored boy, a Mr. Teal... and how kind and sympathetic he was. He is indeed endowed with many good qualities, necessary for the profession he is pursuing. It proved again that no matter what our race, color or creed, we all are brothers under the skin, and are endowed with a great capacity for kindness, understanding, sympathy and love for our fellowman.*

See "1898: Idaho's First African American Physician."

Lewiston Morning Tribune, August 9, 1949, 12.

1951: First Northwest Intercollegiate Rodeo

On May 4, the first Northwest Intercollegiate Rodeo opened in Lewiston. Teams from Washington State College, the University of Idaho, Montana State University, University of Wyoming, Oregon State College, Southwest Texas Junior College, Colorado A&M, California State Polytechnic and

the University of California attended the three-day contest. A colt was donated for the best all-around cowboy. The organization is now centered in Pendleton, Oregon.

Ellensburg [Washington] *Daily Record*, April 6, 1951, 8.

1955: NORTH IDAHO'S FIRST TELEVISION STATION

At 6:50 p.m. on December 9, KLEW went on the air with a ten-minute introductory program followed by a championship boxing match that lasted only two rounds. In the early days of local broadcasting, KLEW chose shows from the three major networks and aired them between 6:00 p.m. and midnight Monday through Friday. On the weekends, programming was seen from noon to midnight. Using rabbit ears, local viewers got their signal from the transmitter and master control center atop the Lewiston Hill. The original studios were located at 1115 Idaho Street. In 1977, KLEW, by then a CBS affiliate, moved its studios to 2626 Seventeenth Street, on the edge of the Orchards. KFXD, Idaho's first television station, went on the air on June 18, 1953, in Nampa.

1962: IDAHO'S FIRST INTERNATIONAL WOMEN'S PROFESSIONAL LOG-ROLLING CHAMPION

Also called birling, the sport began among lumberjacks, who competed to see who could stay on a floating log while the opponents spun it by walking along its surface. Lewiston women have won the world championships six times, the first coming in 1962, when seventeen-year-old Barbara Peterka took the title at the competition held that year in Hayward, Wisconsin. She was followed by Cindy Cook

Barbara Peterka (left) and Bette Ellis, 1959. *Courtesy of Bette Ellis Jordan.*

(1967–70) and Penni McCall (1972). If one includes Bette Ellis Jordan (1958, 1960, 1963–65), who was a resident in neighboring Clarkston, Washington, at the time, the world title has been won a total of eleven times by local women, all under the tutelage of former champion Roy Bartlett.

1967: IDAHO'S FIRST HIGH SCHOOL FM RADIO STATION

On May 20, 1935, KRLC signed on the air for the first time. Active in radio forensics by 1932 while using the facilities at Washington State College (now Washington State University), the Lewiston High School Radio Club was broadcasting twelve programs a week by 1937 from the school through a direct link to the KRLC studios, which were then located in the basement of the Lewis-Clark Hotel. Everyone in class had a job, from on-air speaking to holding up "quiet" cards for the audience. KLHS-FM signed on the air in October 1967 under the leadership of teachers Ed Sanman and Jack McGee. In 2003, the station license was transferred to Lewis-Clark State College.

The History of Idaho Broadcasting Foundation, Inc.

1973: First Removal in the United States of a Federally Licensed Dam to Restore a Stretch of Free-Flowing River

In 1927, a 1,060-foot dam was built across the Clearwater River just east of town to provide ten megawatts of power to and a millpond for the Clearwater Timber Company sawmill, a spinoff project of the Weyerhauser Corporation now known as Clearwater Paper. A sad result of the dam and its inadequate fish ladders was the near extinction of the native chinook salmon. Removal began by opening the spillway gates to lower the reservoir level and then removing the gates and bridge. The spillway was cracked with dynamite and dug out in chunks. After the salvageable steel was extracted, the debris was placed along the north side of the river and covered with soil and vegetation to minimize the impact on the landscape.

Chisholm, Ian. "Removal of the Grangeville & Lewiston Dams in Idaho." Dam Removal Success Stories. Friends of the Earth, American Rivers and Trout Unlimited, December 1999, 27–31.

1974: IDAHO'S FIRST
FEMALE POLICE OFFICER

On January 15, the Lewiston Police Department hired April Norman. The *Lewiston Morning Tribune* exclaimed: "Holy handcuffs, Batman! Lewiston has a lady cop!" Women had worked for police departments previously, but not in patrol capacities. Initially scheduled for parking meter duties, Norman was given a patrol assignment in September. During her four years as an officer in Lewiston, Norman remembered being assigned less hazardous duty than her male co-workers. She cited one example when she was dispatched to investigate the accidental hanging of a child. Upon arrival, her supervisor told her to leave and resume her patrol duties. After four years of feeling she was "over-protected by an old-school supervisor" and other officers in the department who had a difficult time accepting women in their profession, Norman joined the Eugene, Oregon Police Department, which already had female police officers. She retired in 2004 after twenty-five years of service in various assignments, including patrol, crime prevention and detective work and as a school resource officer.

Marriage was something Norman didn't believe likely in small-town Lewiston, especially after all the notoriety of becoming a "first" in a male-dominated and sometimes dangerous profession. "It would take a special person who would have enough confidence in my judgment and common

April Norman, 1974. *Courtesy of April Norman.*

sense to keep myself safe," she once said. She eventually found such a person in Eugene. The first woman to serve in any definable capacity with the Lewiston department was Pauline Morath, who began work in September 1942 as "desk sergeant." Female employees were in charge of clerical work and fingerprinting. See "1863: Idaho's First Female Jail Employee."

Lewiston Morning Tribune, August 31, 1974, 9; March 29, 2004.

1992: IDAHO'S FIRST FEMALE SUPREME COURT JUSTICE AND CHIEF JUSTICE

Linda Copple Trout joined the Lewiston firm of Blake, Feeney & Clark after graduating from the law school at the University of Idaho in 1977. She handled a bit of everything at the firm and served on the board of directors of the Northwest Children's Home, the Lewiston City Library and the YWCA. In 1983, she was appointed as a magistrate judge. At the same time, Trout took on the duties of acting trial administrator for five Idaho counties, a position she would hold from 1987 to 1991. Trout was elected as a district court judge in 1991 and would regularly hear cases in Nez Perce and Clearwater Counties. In 1992, she was appointed to the Idaho Supreme Court, and from 1997 to 2004 she was its chief justice. She retired from the court

in 2007. "It was an honor to be on the Supreme Court—that's how I looked at it. Not that being the first female justice wasn't a part of it. Yes, I was blazing new ground, but I was just honored to be on the court." Commenting on the scrutiny that came with her gender, she noted, "I guess that I felt in my own mind that I would analyze the law like anybody else and

Linda Copple Trout. *Courtesy of the Idaho Supreme Court.*

work hard. From that standpoint there probably wouldn't be much difference." Although retired, Trout continues to serve as a judge in Idaho, working as a senior judge and as a court-appointed mediator and volunteer spokeswoman for the court.

Idaho State Bar Association
Moscow-Pullman Daily News, May 24, 2007, 4A.
Spokesman-Review, February 1, 1997; May 24, 2007.

1992: IDAHO'S FIRST
AFRICAN AMERICAN JUDGE

Ida Leggett. *Courtesy of the Idaho Second District Court.*

Ida Leggett was born and raised in a small town in the middle of Alabama. Her father was a sawmill worker and her mother a schoolteacher. Those were the days in Alabama of separate water fountains. Her parents paid a poll tax to vote, and there were white and colored entrances to the courthouse. An avid reader, she was not allowed to use the all-white city library. She graduated from Gonzaga University (Spokane, Washington) and went into private practice in Coeur d'Alene, Idaho. She was the first African American woman admitted to the Idaho Bar. Within a couple years, she was appointed a member of the Idaho Commission of Pardons and Parole. In 1992, Governor Cecil Andrus appointed Ms. Leggett to a position as a trial court judge in Lewiston, ironically replacing Linda Copple Trout.

She was highly visible as an African American woman, a female professional and an African American female judge. The lack of privacy made her vulnerable to threats. She felt unable to fully relax from her professional role while in public. If she was working in her yard, she could not run down to the local hardware store in her working clothes without everyone noticing and talking. In 1998, Judge Leggett decided the isolation and constant scrutiny of her life was too much. She resigned her position as judge and moved to Seattle, where she later served as the executive director of Washington's Sentencing Guidelines Commission.

Idaho State Bar Association
Spokesman-Review, November 17, 1992, B1.

1995: IDAHO'S FIRST NEWSPAPER TO PROVIDE ACCESS ONLINE

Founded in September 1892, the *Tribune* suffered a disastrous fire in 1909 in its Fourth Street offices that nearly ended the business. The fire resulted in production upgrades. In 1961, the *Tribune* moved into its current building at Capital and Fifth Streets. Again, the newspaper saw new technologies enter its production rooms. The newspaper added an electronic version in September 1995, at a time when the World Wide Web was in its relative infancy and slow dial-

up modems were the height of technology for most home computers. See "1898: Idaho's First Newspaper to Receive Electronic Mail Dispatches."

2011: IDAHO'S FIRST ACCREDITED PUBLIC WORKS AGENCY

The American Public Works Association (APWA) analyzed Lewiston's pubic works department for its performance delivering services that include water, solid waste, streets, sewer repair and maintenance, engineering, storm water drainage and traffic safety. With a worldwide membership over twenty-eight thousand, APWA includes members from local, county, state/province and federal agencies, as well as private sector personnel who supply products and services to those entities. Chartered in the United States in 1937, APWA's roots reach back to 1894, with sixty-three current chapters in North America, with eight chapters in Canada. Lewiston's recognition was only the sixty-seventh to be awarded. Lewiston's public works staff voluntarily submitted to formal verifying and recognizing protocols to assess whether city procedures and processes measured up to industry standards based on a Management Practices Manual developed by the APWA.

2011: FIRST WOMAN TO CHAIR THE BOARD OF DIRECTORS, EDUCATION NORTHWEST

Chartered in 1966 as Northwest Regional Educational Laboratory, Education Northwest conducts more than two hundred projects annually, working with schools, districts and communities across the country to implement comprehensive, research-based solutions to the challenges educators face. Dr. Janette R. Hill, chair of the Education Division (Lewis-Clark State College), became the first woman to lead the forty-five-year-old organization. Dr. Hill has led the Education Division since 1998, joining the faculty in 1989.

ABOUT THE AUTHOR

A widely published historian and career educator of gifted children, Steven Branting has been honored for his research and fieldwork by, among others, the History Channel, the American Association for State and Local History, the Association of American Geographers and the Society for American Archaeology and was a 2009 nominee for the American Historical Association's William Gilbert Award to recognize outstanding contributions to the teaching of history through the publication of magazine articles. In 2011, the Idaho State Historical Society conferred on him the Esto Perpetua Award, its highest honor, citing his leadership in "some of the most significant preservation and interpretation projects undertaken in Idaho."

Visit us at
www.historypress.net
..

This title is also available as an e-book